RAILROADS
IN EARLY POSTCARDS

T0097151

Volume 2: Northern New England

By Stephen Boothroyd and Peter Barney

The Vestal Press, Ltd.
Vestal, NY

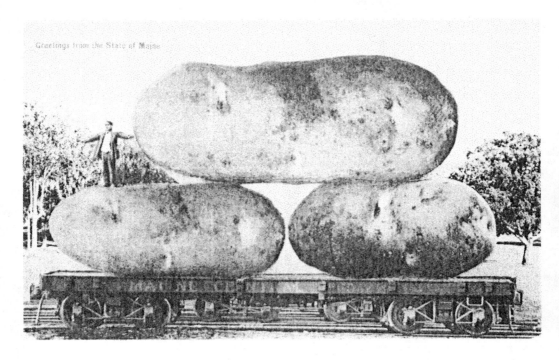

Greetings from the State of Maine

Publishers of postcards have always had a lot of fun producing "gag" cards promoting the products and features of geographical regions and places. This superb example features Maine's agricultural product best known to consumers all over America, the potato. A substantial portion of the revenue freight carried by both the Maine Central and the Bangor and Aroostook Railroads has traditionally consisted of potatoes, not all of which have been of these dimensions.

Library of Congress Cataloging-in-Publication Data
(Revised for vol. 2)

Railroads in early postcards.

 Includes indexes.
 Contents: v. 1. Upstate New York / by Richard Palmer
and Harvey Roehl -- v. 2. Northern New England / by
Stephen Boothroyd and Peter Barney.
 1. Railroads--New York (State)--History--Pictorial
works. 2. Postcards--New York (State)--History.
I. Palmer, Richard F.
TF24.N7P35 1990 385'.09747'022 89-70721
ISBN 0-911572-87-2 (v. 1 : alk. paper)
ISBN 1-879511-04-5 (v. 2 : alk. paper)

© 1992 by The Vestal Press, Ltd. All rights reserved.
Printed in the United States of America

Cover design by Don Bell

Published by Vestal Press, Inc., 4501 Forbes Boulevard, Suite 200, Lanham, Maryland 20706

[Editor's note of explanation for non-rail buffs: groups of numbers like 4-4-0 refer to the wheel arrangement of the steam locomotive. It means there are four pilot wheels in the front, four driving wheels, and no trailing wheels; the descriptive term for this is the "American" type. A 4-6-2, by comparison, is known as a "Pacific" — it has four pilot wheels under the front of the boiler, six driving wheels, and two trailing wheels under the firebox. This nomenclature, known as "Whyte's Classification" has a long list of different arrangements.]

CONTENTS

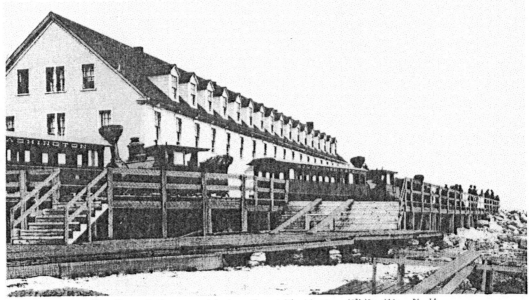

The Summit House and trains, Mount Washington, White Mts., N. H.

The Summit House hotel was built atop New Hampshire's Mount Washington, the highest peak in New England. It was reached by the world-famous Mount Washington Cog Railway, a unique railroad by any standard. The original Summit House was a stone hotel built in 1852. The second Summit House, shown here, was built in 1872-73 of materials hauled up the mountain by the Cog Railway. It served until 1908 when it was destroyed by fire. A replacement summit house of similar design was built in 1915, and stood until the 1980's when, sadly, it was demolished to make way for a visitor center.

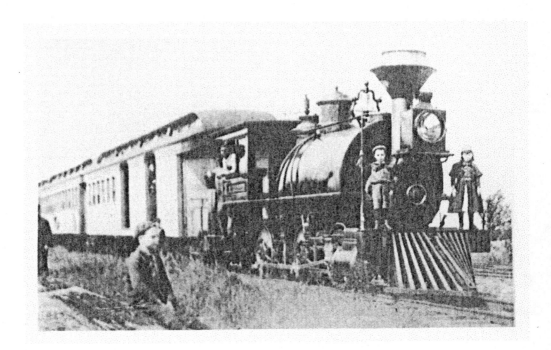

The-three-foot-gauge Profile and Franconia Notch Railroad was built to serve the Profile House Hotel in New Hampshire's scenic White Mountains. The little line ran for 42 years, until abandoned in 1924. The 0-6-0 "Saddle Tank" engine (with its water supply tank straddling the boiler) shown here worked on the three-and-a-half-mile-long Bethlehem Street branch, puffing back and forth with its little train to the obvious delight of young and old alike.

INTRODUCTION

There was another time, not so very long ago, but seemingly a world away. As we approach a new century it is altogether fitting that we should look back at the beginnings of the present one. In what better way can we do this, but through that uniquely twentieth century phenomenon, the picture postcard?

The railroads of northern New England connected rural communities together in a lacework pattern of intersecting rail lines built mostly in the nineteenth century. Railroads such as the Somerset; the Washington County; and the Boston, Concord, and Montreal to name a few built in that era, joined the small towns together, spreading the benefits of civilization to all the people.

It truly was an optimistic age. Progress was being made at every turn, as travel became possible and convenient. Local economies expanded for upon those steel rails it was possible to travel at the unheard-of speed of forty or even fifty miles per hour!

Once the rails wove an incomprehensible spider's web across the face of New England. Then slowly the smaller roads were joined together to form larger systems like the Boston and Maine; the Central Vermont, the Maine Central; and the lilliput giant the Sandy River and Rangeley Lakes, with consolidations of personnel and equipment.

The faster trains and improved service of the years prior to the first World War were captured on postcard views showing the prominent position that the railroads held in their communities. Views of bridges, trains, stations and railroad yards were printed both in the United States and Germany where the hand coloring of views was a specialty. These images reflect the spirit of a time not so long ago, but seem oh, so far away.

Today many of these railroads are gone, as are the men who built them. They were abandoned in the hard times of the depression or, as in more modern times, torn up as the bulk commodities necessary to sustain a modern railroad have departed the local communities. In some cases the stations are still in use on active lines. Others have been preserved by local historical societies, and some have been renovated to lead another life as a bank or restaurant. Still, in so many cases all that remains are photos and relics.

So, as we look back at the past through our rose colored windows, these authors offer their salute to those railroaders and the half-forgotten lines upon which they ran.

HIGHBALL!

About the authors

Stephen Boothroyd

Stephen Boothroyd's attraction to things which clink, clank, and hiss dates to a tender age. He recalls with delight when, as a child of six, he watched street repairs in front of his Pennsylvania home being conducted with a cinder-belching steam-powered shovel. He greatly enjoys remembering the hearty laugh and warm smile of the begrimed man who offered the neighborhood children rides up the street on the clanking machine. The warmth of the fire and the roar of the steam that became etched in that small boy's mind remain three decades later.

Later, trains and textile mills were added to the list of things that fascinated him. Given that, it is hardly surprising that his first published work, written when he was seventeen, was about trains. His by-line has appeared in many railroad hobby publications, including *Railroad Modeler*, *Narrow Gauge Gazette*, *Prototype Modeler*, and *Rail Classics*. He now operates a retail hobby store.

A graduate of the University of Rhode Island, he resides in Wakefield, Rhode Island, with his wife Marilyn and their two cats, George and Gracie.

Peter Barney

Peter Barney is a native of New Bedford, Massachusetts, and inherited his life-long love of trains and scale-model construction from his father. He is a graduate of Bridgewater State College with a degree in English and Education.

In the early 1980's he was the editor of *Prototype Modeler* magazine, and today is a continuing contributor to *Railroad Model Craftsman* magazine. Mr. Barney is also noted as the author of six books on the Maine two-foot-gauge railroads.

Mr. Barney is active in civic affairs and has served the City of New Bedford as City Treasurer and Tax Collector, and currently is the City Assessor.
He resides in New Bedford with his wife Joan and son Jamoson.

Acknowledgements

The authors wish to thank those who have helped make this book possible. Valuable cards were loaned by Douglas Stamford of Charlestown, Rhode Island, and Barbara Clark of North Woodstock, New Hampshire. They also express their gratitude to Joseph and Alice Flagg who beyond the call of duty put up with nocturnal comings and goings, and especially to Alan Thomas of North Woodstock who not only shared his knowledge of New England railroading, but also patiently waded through the text to ensure accuracy. The authors wish to emphasise that any errors of fact or interpretation are their own.

CANADIAN PACIFIC RAILWAY in Vermont

The Canadian Pacific's crack *Red Flyer* blasts across the Missisquoi River bridge southbound at North Troy, Vermont. Between Newport and Richford the Canadian Pacific takes a rather serpentine course looping back and forth across the border between Vermont and Quebec. The bridge shown in this 1912 postcard was replaced in 1990, although the *Red Flyer* had long since faded to just a pleasant memory.

The *Red Flyer* is being pulled by a rare 4-cylinder Vauclain compound 4-4-0 built by the

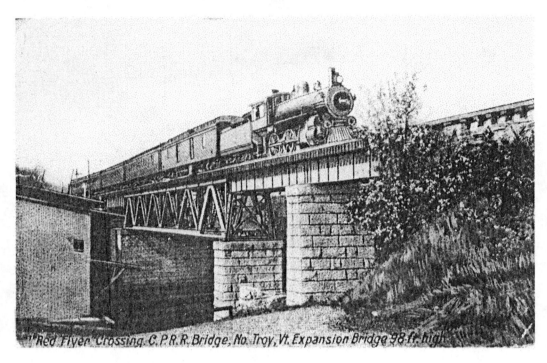

"Red Flyer" Crossing C.P.R.R. Bridge, No. Troy, Vt. Expansion Bridge 98 ft. high

Baldwin Locomotive works. Compound locomotives, which pass the expanding steam through two sets of cylinders instead of one before exhausting it to the atmosphere, were popular around the turn of the century as they produced more power than conventional locomotives, but they were soon outmoded by improved designs.

The great floods of November, 1927, were the worst in the history of Vermont. Eighty-four people, including the state's Lieutenant Governor, died. Statewide, 28 million pre-depression dollars' damage was done. Here a steam powered Canadian Pacific pile driver is shown working to save an under-mined bridge across the Missisquoi River near Richford, Vermont.

All of Vermont's railroads were hard hit by the flooding. The Central Vermont practically

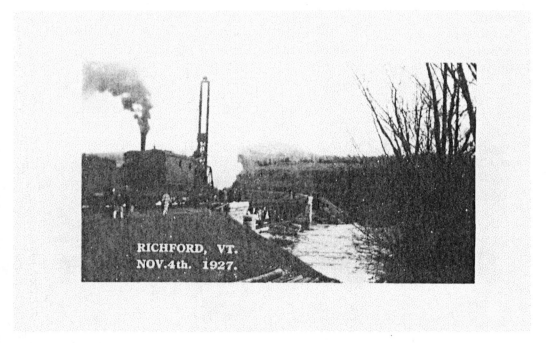

RICHFORD, VT.
NOV. 4th. 1927.

ceased to exist. Three months, twenty-three wreck trains and three thousand men were needed to reopen the line. The cost bankrupted the Central Vermont, putting it in the hands of receivers for years to come.

On the Rutland, frantic railroaders saved some bridges by parking trains loaded with gravel and stone on top of them. Some of the earthen fills were saved when old cars were tipped off the tracks to create makeshift breakwaters around the bottoms.

RUTLAND RAILROAD

The rails of the Rutland and Burlington Railroad reached Burlington, Vermont, on December 18, 1849, just two weeks before those of its arch-rival the Vermont Central arrived. Although the Rutland won the race to Burlington it was the Vermont Central which won the war. The Vermont Central bypassed Burlington, isolating it on the end of a stubby branch line, while their main line passed to the east on its way to the expanding markets of Canada and the American west, leaving the

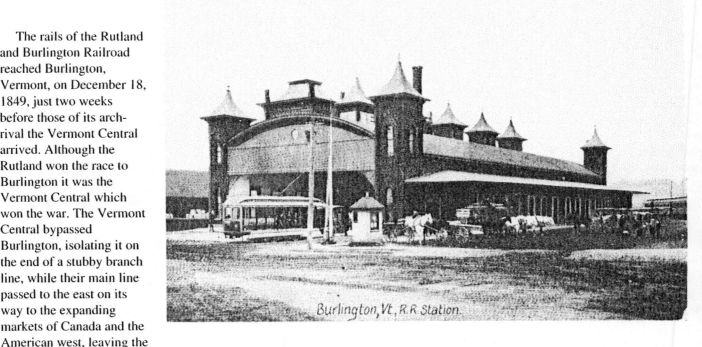

Burlington, Vt, R.R. Station.

Rutland with northern connections via either an uncertain ferryboat or the hostile Vermont Central. The inevitable result was that the Rutland fell under the contol of its rival until 1896, when the Vermont Central was itself swallowed up by the Central Vermont.

In 1900 the Rutland completed a new line skirting the beautifully wooded shores of Lake Champlain to Alburg, just south of the Canadian border. From Alburg reliable all-weather connections to the west were established which, more than anything else, allowed Burlington to grow into the city it became.

At Burlington trains pulled right through the original depot, out of the weather under a protective train shed, while depot hacks lined up outside to take travelers to their destinations. At the turn of the century 11 miles of street railway served the city, running out of the depot.

Fort Ethan Allen from Water Tower, Burlington, Vt.

Fort Ethan Allen was named after Vermont's most famous Revolutionary War hero. Leading his Green Mountain Boys, Allen captured Fort Ticonderoga, on the New York side of Lake Champlain, from the British in 1775 without firing a shot. His stern command for its immediate surrender "in the name of the Great Jehovah and the Continental Congress" galvanized the country.

Fort Ethan Allen was located midway between Burlington and the Central Vermont at Essex Junction and was served by both steam railroad and electric trolley connections.

Allen is buried in nearby Burlington, his final resting place marked by a spire of white marble.

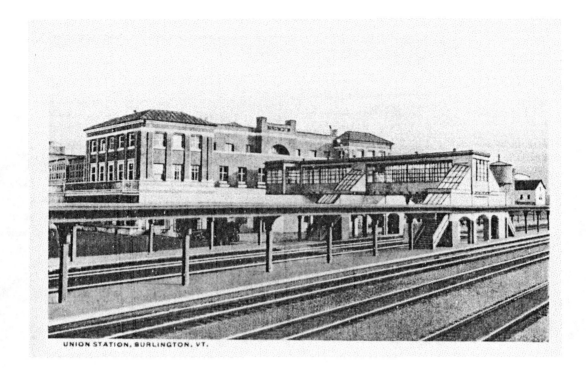

UNION STATION, BURLINGTON, VT.

In 1916, at the height of passenger travel, a modern Union Station was erected at Burlington. Although bereft of unnecesary ornamentation the new Union Station was still cheerful, bright, and efficient. The spacious and brightly lit waiting areas had walls of fine white marble, from Vermont, of course. Waiting rooms were on the second level and connected to the passenger boarding platforms by means of a glass-enclosed pedestrian overpass which undoubtedly was a welcome relief from the dark smoke-filled confines of the preceding station's train shed.

In 1961 a strike closed the Rutland railroad forever, and the station was developed into offices of the Central Vermont Power Company. The track north of Burlington was abandoned by the Vermont Railway, successor to the Rutland. Today only the decaying trestle and its protective marble rip-rap remain along the shore of Lake Champlain between South Hero Island and Colchester Point to mark the passing of the once-proud Rutland Railroad.

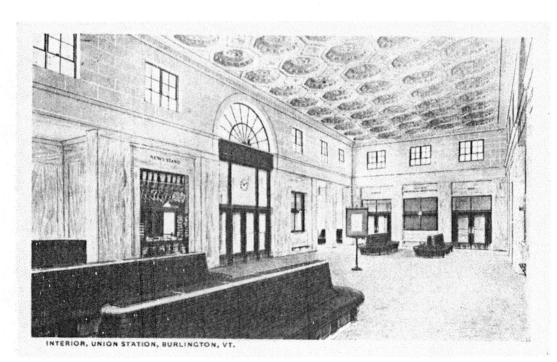

INTERIOR, UNION STATION, BURLINGTON, VT.

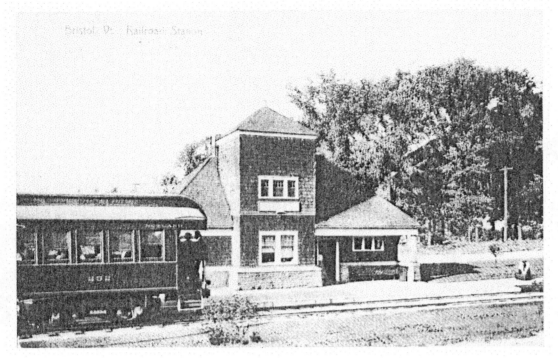

The seven-and-a-half-mile-long Bristol Railroad puffed its way onto the map in 1890. Trains left the Rutland main line at New Haven Junction to reach Bristol, and the original power used was a rear-tank 0-4-4 Forney locomotive.

Rear tank engines were popular on branch lines built with very light rails. They looked much like conventional steam locomotives though typically the bobtailed tender attached to the back of the cab had only one four-wheeled truck supporting it. The short length of the boiler required that the bell be perched atop a tall dome on the boiler, and since the engine was not turned around at the ends of the short run, it was fitted with a headlight and cowcatcher pilot both front and rear.

The Bristol branch was used for forty years. In later years a penny-pinching gasoline-powered railcar was used on the run before service ceased during the great depression. The depot shown here lasted into the 1960's.

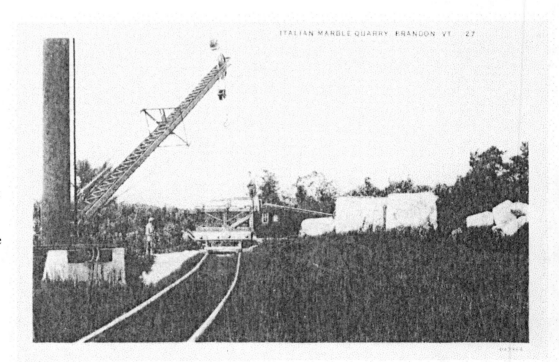

ITALIAN MARBLE QUARRY BRANDON VT. 27

The area immediately south of Brandon is the heart of Vermont's marble producing region. Our word "marble" comes from the Greek word for "sparkle." The fine crystal facets in the marble reflect light and produce a brilliant sheen when the stone is polished.

While Vermont's marble is not sufficiently fine grained for large scale sculpture, it is especially well suited for use in architecture and monuments. In the Italian marble quarry blasting powder was sometimes employed, but most of the Vermont quarries used a device called a "channeler" especially designed to work in the kind of marble found in the region. A row of long star chisels were set in a framework which, when set in motion, would move up and down to cut a groove in the rock. Eventually this groove would be expanded with wooden wedges driven in with mallets in order to split off a slab.

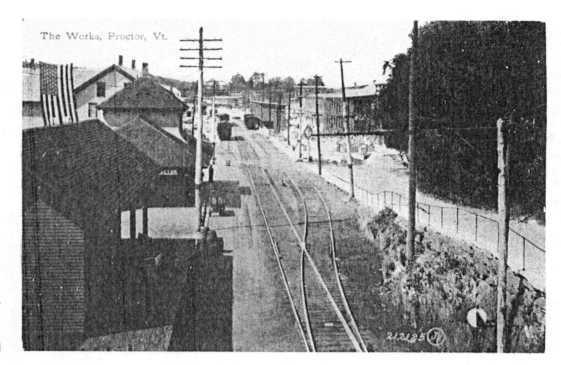

The Works, Proctor, Vt.

Since the 1830's some of the largest marble quarrying operations in the world have been operated along Otter Creek, in and around Proctor, Vermont, four and a half miles north of Rutland. Originally called Southerland Falls, the name Proctor was adopted in the 1870's to honor Redfield Proctor Sr., The Works' energetic foreman.

At The Works the worlds' largest marble finishing shop was operated. This shop, over 1,000 feet long, was equipped with scores of giant saws for cutting the huge quarry blocks, and hundreds of workers were employed. In the era before the depression the output of this single shop was typically over $3,000,000 annually.

The giant gang saws used to cut the stone blocks are fascinating machines. A toothless blade of soft malleable iron or steel one-sixteenth of an inch thick and about four inches wide cuts into the marble, assisted by a stream of water carrying sharp silica sand down into the saw kerf. After sawing, the marble is wetted and polished with other smooth stones, followed by wood and finally cloth. In the lower view, an impression of volume of stone quarried can be seen in the stacks of blocks awaiting shipment.

The quarries and works had their own railroad, the Clarendon and Pittsford, a shortline which continues to operate as this description is written.

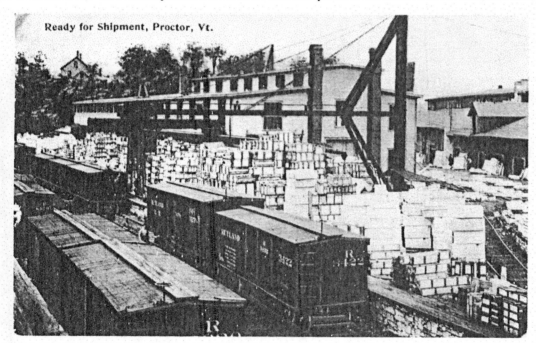

Ready for Shipment, Proctor, Vt.

The city of Rutland was the heart of the Rutland Railroad. The Rutland's predecessor roads met there, and it was the junction of the wonderfully scenic Bellows Falls branch as well as the Delaware and Hudson's connecting line from Whitehall, New York.

In the early days locomotives were serviced at Rutland in a most unusual completely enclosed roundhouse with its turntable inside. Locomotives entered through a portal and were turned into their stalls for service, all snug and warm under a tall dome.

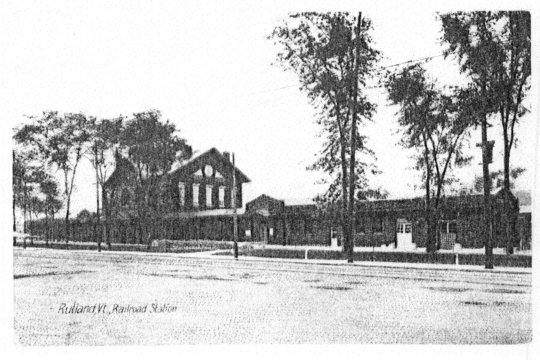

Rutland Vt. Railroad Station

The depot shown here served the road's passengers until passenger service ceased, following a strike in 1953. After the abandonment of this service the depot was demolished, in the mid-1950's

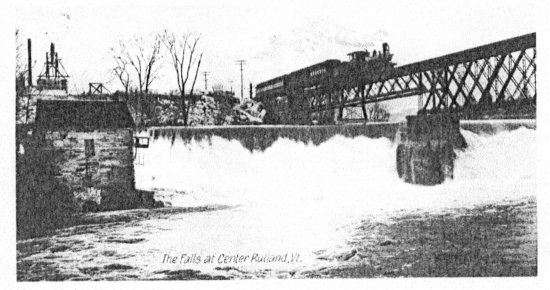

The Falls at Center Rutland, Vt.

The Delaware and Hudson Railroad operated into Rutland over a connecting line from Whitehall, New York. At Center Rutland, a few miles south of Proctor, the line crosses directly over this spectacular falls on the Castleton River. This westbound train has just left Center Rutland depot, out of sight beyond the bridge and is headed out across the falls. What a sight the passengers on this train must have had!

Although the deck truss bridge seen here has been replaced by a single-span through truss bridge the falls are every bit as spectacular today as they were at the turn of the century.

At each end of the falls was a power house where a turbine operated a generator for making electricity; the one at the left, shown here, is still standing. The power house is made entirely of marble blocks and is protected from erosion by a rip rap of broken monument stones, many inscribed with names and dates. (Barbara Clark collection)

6

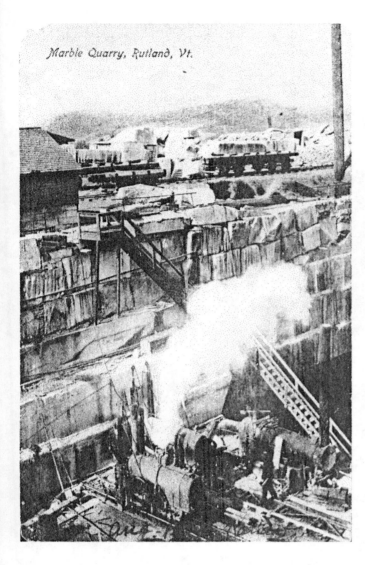

Marble Quarry, Rutland, Vt.

As at nearby Proctor, marble quarrying was an important industry around West Rutland. The stone was cut from ledges, the edges of which in many cases dropped literally hundreds of feet to the bottom of the quarry. After being cut free from the ledges the huge blocks were dragged to the edge of the pit on special heavy-duty quarry cars, then hoisted to the surface using large, powerful cranes like the one at the right in this view. All these were powered by steam engines, turning drums and pulling cables. In the final step the blocks were loaded on heavy-duty flatcars, as seen at the top of the picture, to be taken to the stone cutting sheds.

At the stone cutting sheds the blocks were unloaded from their flatcars and moved inside by a gigantic overhead crane several stories tall. One leg of the crane is shown in the middle of this view. The blocks in the foreground are quarry blocks; note the drill marks indicating where they were split apart.

This view shows work at the Vermont Marble Company's works numbers 19 and 20 at West Rutland. At the turn of the century these plants operated 24 hours a day, seven days a week, while crews fed the stones through the 48 big gang saws located there.

This view also gives an interesting peek into turn-of-the-century railroad practices. These cars are being rolled into position for unloading with the aid of gravity and with the brakemen on the cars handling the brakes. The nearest brakeman has a stick called a "brake billy" in his hands, used to gain leverage on the brake wheel in setting the brakes tighter. As each car is loaded the brakes were be released and the next car in line would roll into position for unloading.

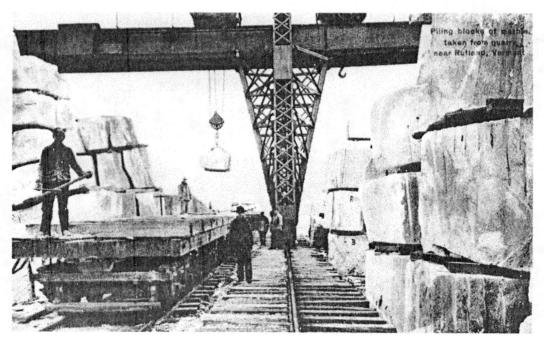

Piling blocks of marble taken from quarry near Rutland, Vermont

This unfortunate locomotive blew up near Proctorsville in 1923, thanks to failure of the "crown sheet," the large piece of sheet steel that covers the firebox and separates it from the boiler water above it. If for any reason the sheet is allowed to become dry, it quickly gets red hot (just like running a tea-kettle dry on the kitchen stove) and as soon as any water reaches it, steam is produced faster

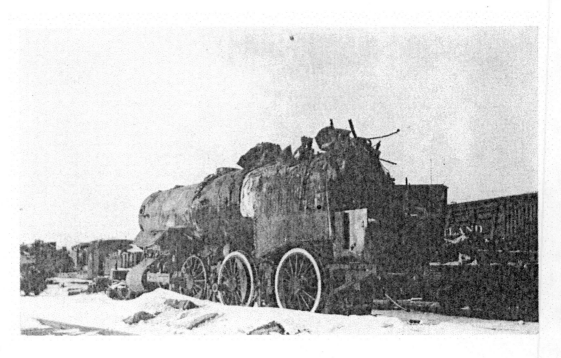

than the boiler can handle it and an explosion is the usual result.

This wreck, which surprisingly is not damaged beyond repair, has been towed into Rutland for reconstruction and eventual return to service. Locomotive buffs will note that this turn-of-the-century locomotive shows its obvious Brooks design heritage in its inboard piston valve cylinder arrangement.

The Rutland Railroad was a heavy purchaser of American Locomotive Works products and many engines built by their Brooks Works were still soldiering on for the Rutland long after other roads had consigned theirs to museums. In fact, with the exception of some fine wartime 4-8-2's, the Rutland's entire steam era roster could be termed antiques.

Legend has it that the 53 miles of track from Rutland to Bennington follows an old Indian trail. The native Americans must have been practical travelers, for this stretch of track was also the easiest on the line. South of Bennington the Rutland met the 57-mile-long Lebanon Springs Railroad, a winding line which ran through to Chatham, New York. In 1901 the Rutland purchased the Lebanon Springs to obtain an outlet into New York City, and for many years the Rutland's fast milk express trains wound their way down the "corkscrew division" on their way to the market.

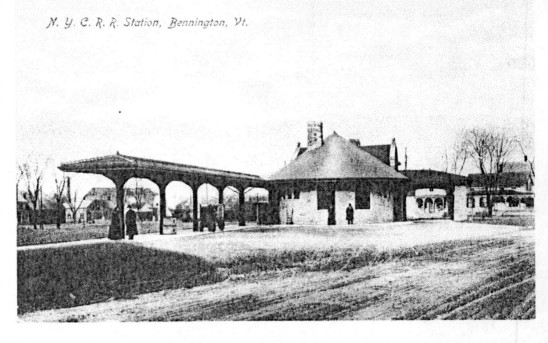

N. Y. C. R. R. Station, Bennington, Vt.

In the nineteenth century the Rutland fell under the control of the Vermont Central Railway, regaining its independence in 1896 only to fall under the domination of the New York Central System eight years later. Although some moves were made toward absorbing the Rutland into the New York Central, a deal was hatched by which the New Haven Railroad obtained half ownership; the happy result of this was that the name Rutland reappeared immediately on the locomotive tenders. That is the reason that this post card, which dates to about 1914, describes the station as belonging to the New York Central.

Bellows Falls Branch

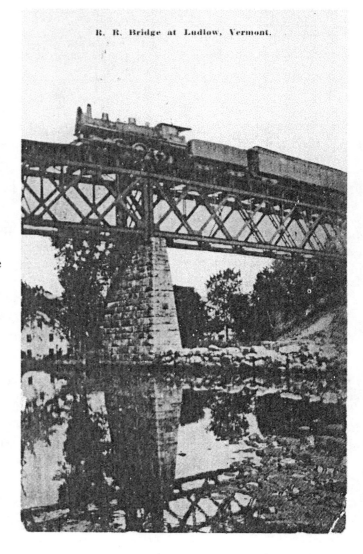

The Bellows Falls branch of the Rutland left the main line at Rutland, Vermont, and cut diagonally across the lower half of the state. This passage through the rugged Green Mountain range provided an incredible contrast of steep mountains and deep river gorges. Perhaps the most photographed spot on the Rutland was the high bridge at Ludlow, 27 miles north of Bellows Falls.

In this photographic post card, postmarked in 1912, a westbound section of the Green Mountain Flyer pounds across the steel span behind one of the Rutland's Brooks ten-wheelers.

A strike closed the Rutland Railroad in 1961. In 1963 the line was abandoned and the State of Vermont claimed the trackage. The Bellows Falls line was leased to the Green Mountain Railroad which continues to operate that portion of the line. At this writing, bulk shipments from the talc mills in and around Chester and Ludlow are an important source of revenue for the Green

The Station, Chester, Vt.

Mountain Railroad, traffic which has developed since the close of the Rutland.

Located about 13½ miles north of Bellows Falls, Chester is midway between there and Ludlow. It's in the midst of some of the best scenery on the line and was the destination of many steam-powered excursions run in association with Steamtown, USA before the museum moved to Scranton, Pennsylvania, in 1985.

This depot is still very much in use at this writing, serving as the headquarters of the Green Mountain Railroad, although its appearance differs from what it was when the card was published.

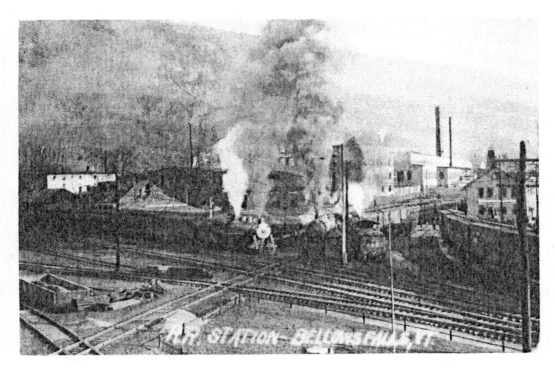

It seemed that every train entering Bellows Falls crossed the diamond in front of Union Station at some time during its visit. In this view, which appears to have been taken from the roof of the Rutland's enginehouse, a Rutland-bound train is at the left, while a Boston and Maine passenger train headed for White River Junction waits for clearance in the center. A switch engine wisely stays in the clear at the right.

An old-fashioned ball signal protected the crossing. Its operator was housed in the tiny shingled shack barely visible between the B&M locomotive and the switch engine. The signal operator must have had the best seat in the house for train watching as at the height of rail service up to eighteen passenger trains a day and numerous freights rumbled through just a few feet from his perch.

Bellows Falls, Vermont, was one busy place. Surrounded by spectacular mountains and rushing rivers which forced all the railroads entering or leaving Vermont into a single gateway, it was a rail enthusiast's dream, for where else could trains from all of the region's major carriers be seen at the same station in one day?

The Rutland entered town from the northwest. The Boston and Maine's Connecticut Valley line came south to Bellows Falls almost straight from the Canadian border. The Central Vermont enjoyed track rights over the B&M

Union Station Bellows Falls, Vt.

from White River Junction to Brattleboro and made its way into town over that same line, while another B&M line from Keene, New Hampshire, snuck in from the east. On occasion Maine Central power would head up B&M trains or Canadian National locomotives might head up one of its subsidiary Central Vermont's trains.

10

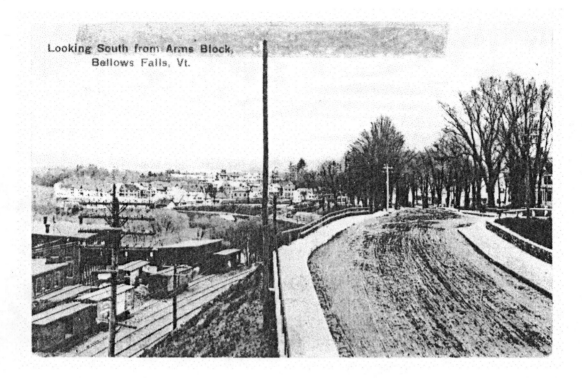

Looking South from Arms Block,
Bellows Falls, Vt.

The Rutland Railroad had a small yard in Bellows Falls, and just across the Connecticut River the Boston and Maine had one in North Walpole, New Hampshire. The yards were located on a small island formed by a loop in the river on three sides and a power canal on the other. Four bridges, all built to different designs, provided access to and from the yards and depot, as well as providing favorite train-watching spots for generations of enthusiasts.

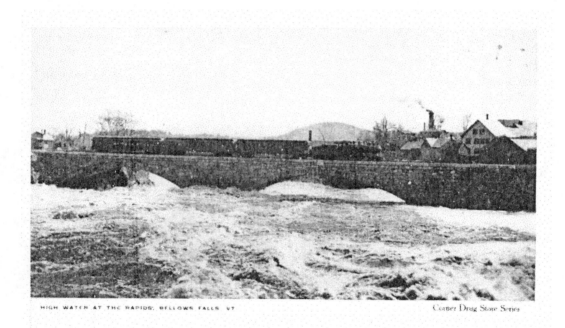

HIGH WATER AT THE RAPIDS, BELLOWS FALLS VT Corner Drug Store Series

A sudden spell of unusually warm spring weather caused the Connecticut River to rise unexpectedly, and the moment has been captured for us by a local photographer who snapped this northbound Boston and Maine passenger train crossing the flood. Today this two-arch stone bridge is still very much in use, although the river is a mere trickle running 100 feet lower than shown here, as the river is diverted through a hydroelectric generating station. The Rutland's successor, the Green Mountain Railway, has its engine-servicing facility at the east end of this bridge.

CENTRAL VERMONT RAILWAY

St. Albans, just 15 miles south of the Canadian Border, is the home of the Central Vermont Railway. A roundhouse and shop complex were located there and in 1866 a new station with an attached train shed and company offices were built. The train shed, measuring 88 x 351 feet, was sturdily built of red Vermont brick in the latest Victorian syle. The attached offices showed considerable French influence in their Mansard-roofed towers and arched windows.

C. V. RAILWAY STATION, ST. ALBANS, VT.

Since the end of the age of steam, the shops have been closed and the train shed has been torn down. Still, the company office continues to operate out of the handsome brick headquarters.

During the Civil War St. Albans gained the unwelcome distinction of being the northernmost battleground. On October 18, 1864, twenty-one Confederate raiders descended on the town, robbing three banks and starting a few fires in the course of their stay. One resident, ironically a Southern sympathizer, was killed by the raiders who suffered three wounded before they escaped back into Canada at nightfall.

Railroad Station, Waterbury, Vt.

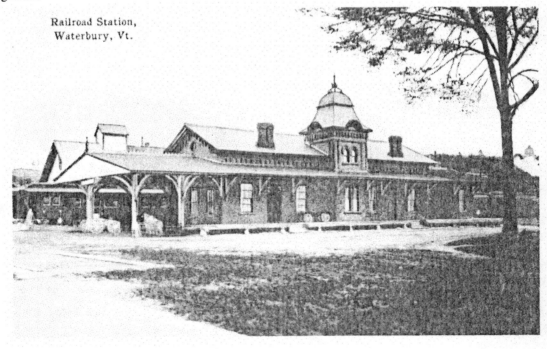

This beautiful brick depot served patrons of the Central Vermont at Waterbury, Vermont, 11½ miles north of Montpelier, until the end of passenger service on the line. In the years since, fire has ravaged the old depot, and at this writing it stands roofless and boarded-up, awaiting an uncertain future.

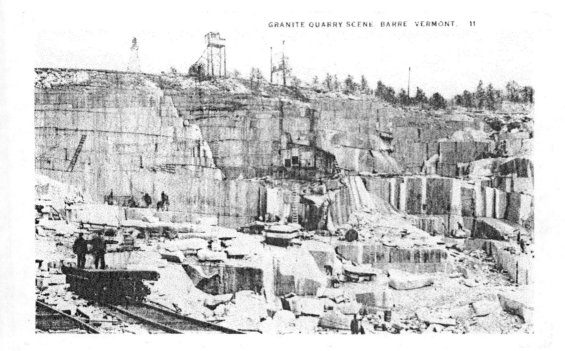

Barre sits atop a distinctive gray granite outcropping, three miles long by a mile wide, which has been quarried since the 1820's. Rail service into Barre began in 1888 with a short line switchbacking (doubling back and forth on itself in order to gain altitude without resort to virtually impossible grades) its way right up the quarry pits.

Steep grades and heavy loads often combine to cause runaway trains, and the Barre Railroad was no exception. One day in 1893, the locomotive *Mountain King* lost its brakes on the downgrade. The crew joined the birds, and the train wound up in a heap of stone blocks and spare parts. A 12-year-old boy who had been hitching a ride down on the cars was found unhurt in the wreckage. The local newspaper recorded the boy's telling rescuers "I have had a heavenly ride."

The name Barre has an interesting local legend associated with it. It seems that Barre was originally called Wildersburgh but the name didn't sit well with all the residents. One faction wanted to call the town Holden and another wanted Barre. The question was decided by that most democratic of expedients, a fist fight in a local barn between the champions of the rival factions. After a few preliminaries the two were soon rolling about on the floor. When the contest was decided the victor rose and declared, "The name is Barre, by God!" after which the local doctor was summoned to remove a particularly large splinter from the victor's backside.

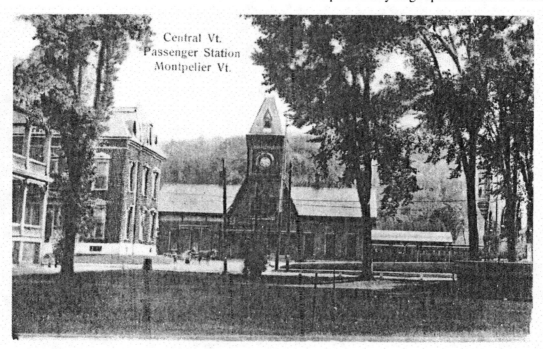

The Central Vermont's main line bypassed the state capital at Montpelier, and a mile-and-a-half-long branch line was need to reach the city. Illustrated here is the Central Vermont's second Montpelier station. This depot, which incorporated a portion of the original, was opened for business in October of 1880.

Understandably, finding their state capital stuck on the tail end of a spur did not sit well with local residents. The locals soon banded together and the 45-mile-long Montpelier and Wells River Railroad puffed its way onto the map, connecting Montpelier with the Boston and Maine off to the east.

The building of the Vermont Central through the hilltop town of Northfield instead of Montpelier, the state capital nine miles north, was accompanied by controversy. Wags of the time said the only reason the Vermont Central went there, instead of a more easterly route with easier grades, was because the railroad's president, Governor Charles Paine, owned a lot of land in Northfield and wanted to make a killing when he sold it. One might suppose that it didn't hurt any that Governor Paine also owned a textile mill in Northfield.

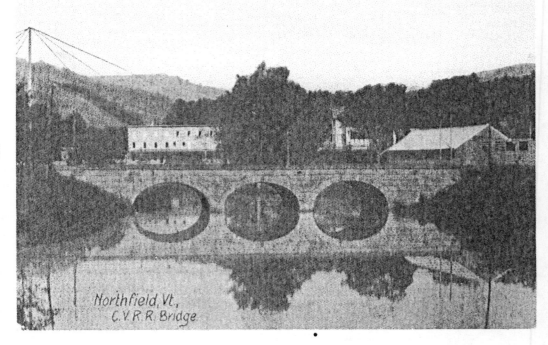

Northfield, Vt.,
C.V.R.R. Bridge.

Some of the land Governor Paine had was sold to the railroad at a fairly liberal price, and a division layover point, shop, and station were built there.

When word came that the Vermont Central was bypassing the state capital, Montpelier, in favor of Northfield, the residents of the capital were outraged. Directors who came from Montpelier resigned and many stockholders refused to pay their pledges, but the road still went through Northfield.

The handsome brick station at Randolph, Vermont, about 33 miles north of White River Junction, was the centerpiece of the community during the railroad era. It was located right on the main street, and featured a siding across from the depot where local merchants could pick up their shipments directly from the cars. The depot stands today, in use as a convenience store.

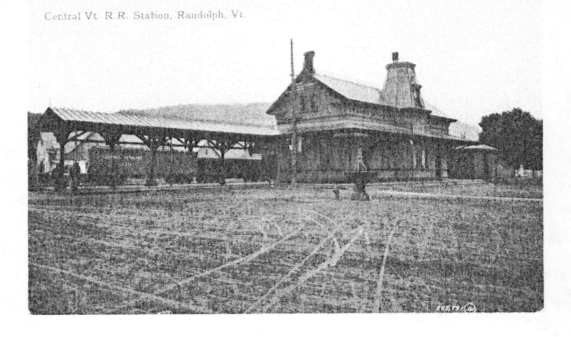

Central Vt. R.R. Station, Randolph, Vt.

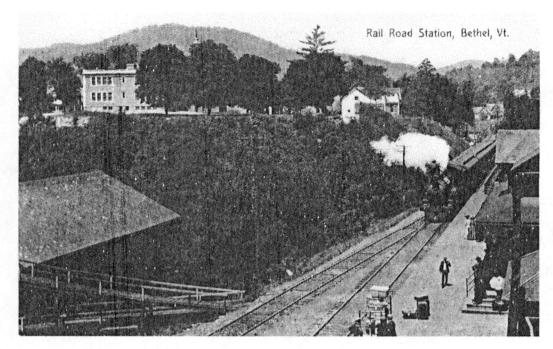

Rail Road Station, Bethel, Vt.

The first train to run in the state of Vermont ran between White River Junction and Bethel on June 26, 1848, following along the course of the White River in negotiating the eastern slope of the Green Mountains. Bethel is a fairly typical town of the railroad era, with a few sturdy houses and businesses, a freight house for the local farmers, and a short branch down to a granite quarry about a mile below the station, all clinging to the steep walls of the river valley. Like many railroad towns where the tracks follow the course of a river, the town is strung out like beads fronting the track on one side and facing the main streeet on the other. The brick station is still standing today, in use as a restaurant with the appropriate name of Bethel Depot.

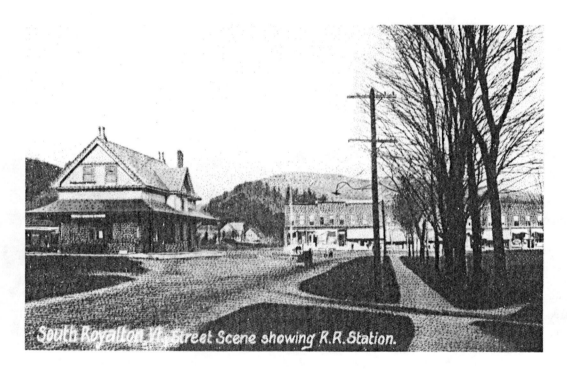

South Royalton Vt. Street Scene showing R.R.Station.

South Royalton, Vermont, is located about midway between Bethel and Sharon. The station there has always represented, to these authors, the epitome of the classic New England country depot. With its typically New England understated ornamentation and sturdy demeaner it was an ideal candidate for adaptive reuse following the end of its days as a passenger depot. The station survives to this day, in use as a bank, following a most commendable job of remodeling which in no way detracts from its historic appearance as a railroad station.

When the writers captioning this 1907 view described Sharon as being in a picturesque setting they were certainly putting things mildly. Fourteen miles from White River Junction, the tidy little brick depot appears tucked away in a tranquil hollow that seems to belie the incredibly difficult passage through the Green Mountain range. Sharon, in reality, is surrounded by mountains on all sides and is reached by following the

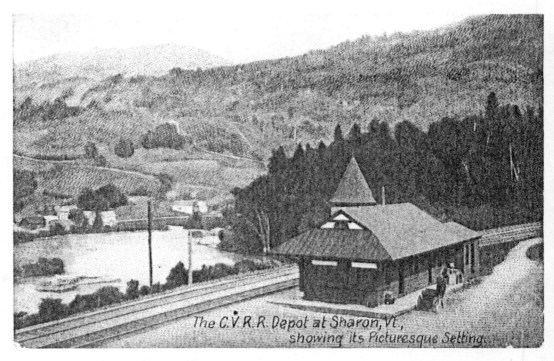

The C.V.R.R. Depot at Sharon, Vt., showing its Picturesque Setting.

course of the White River seen flowing past the depot, located on the opposite wall of the river valley from the village. The photograph from which this view is taken was made from part way up a mountainside which rears up almost immediately behind the depot.

The New England States Limited was the daylight express running between Boston and Montreal in the years before the first World War. It was called a "limited" because it operated on a rigid time schedule with only a few stops and all other trains were ordered to make way for its schedule.

The southbound *New England States Limited*, shown here near St. Albans, originated at Montreal and raced over tracks of the Central Vermont to White River

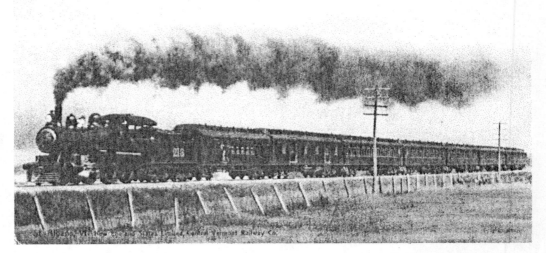

Junction, Vermont, where the crew and the motive power were changed and the train was handed over to the Boston and Maine which took it on to Canaan, New Hampshire. There the northbound section was met, before speeding diagonally across the heart of New Hampshire to Concord, then dipping south into Massachusetts and reaching Boston.

After the war the name was dropped and the train became known simply as numbers 307 and 332. Later those trains were upgraded to become *The Ambassador.*

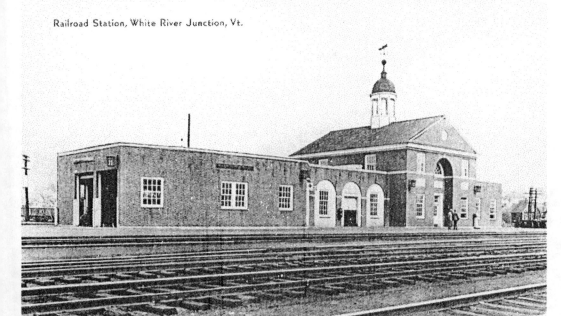

Nestled in a narrow valley where the White River joins the Connecticut, White River Junction has the distinction of being Vermont's original railroad town. Railroads were little more than curiosities when the first train to operate in the state of Vermont puffed out of town back in 1848. Soon tracks radiated out from the junction in all directions.

The landmark brick colonial-style station shown here was built in the 1920's and, as befitted a major junction point, featured a Fine Restaurant. The cupola with the handsome locomotive weathervane atop the station might have looked right at home on many an ivy covered New England college campus.

The 36-mile-long West River Railroad began life as a narrow-gauge line back in 1878. Money was tight back in those narrow-gauge days and the line was soon legendary for the trouble it could get itself into. Rock cuts were barely wide enough, and if a car or locomotive were to sway the wrong way, it was entirely likely that it might make the acquaintance of some adjacent immovable object. Indeed, when the West River was converted to standard gauge and absorbed into the Central Vermont a local wag reported that the worst projections had already been worn smooth by being struck by passing trains.

Newfane, a few miles outside of Brattleboro on the West River line, was located at the summit of a heavy grade which tested the mettle of the little pufferbellys headed both north and south. Sometimes the train would stall and the cars would be hauled to the top a few at a time in a time-consuming project called "doubling the hill." One early-day trainman was said to have enjoyed those times as it allowed him an extra half-hour to court a local widow who lived in a house alongside the tracks.

Winter was even worse. Snow and ice conspired with the stiff grade to stall many a train on the hill. Trains got snowbound so often that a local jokester remarked that the only reason that the town needed its two hotels was to take care of all the stranded passengers. (Douglas Stamford collection)

Tucked away in the southeastern corner of the Green Mountain State alongside the Connecticut River is Brattleboro. Brattleboro has been a railroad town since 1851 when the Vermont Valley Railroad built 24 miles of track connecting it with Bellows Falls.

In those early days the big event was the annual Brattleboro Valley Fair. It seemed that everyone attended, and many arrived by train. At times there weren't passenger coaches enough to accomodate all who wished to attend, and the overflow was handled in "side-door Pullmans,"

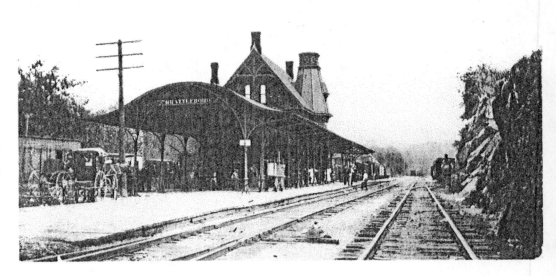

boxcars in which rough planks were laid across boxes to make crude benches.

One year a sudden drenching rain began just after the fair had closed, but before the cars had pulled into the station to take the crowd home. There was, of course, a mad rush to get under the platform roof and inevitably there wasn't enough room under the overhang for all. In the crush women screamed and fainted and many were pushed out into the rain. One account of the event tells about an enterprising member of the gentle sex who pulled out her hatpin and proceeded to use it upon the hindquarters of an uncouth young man who had elbowed her out into the rain.

This depot is gone, replaced by an Amtrak ticket window in a subterranean walkout which once housed a store.

Brattleboro's position between the mountains and the river ensured plenty of grand scenery and lots of handsome bridges. In this view known to the locals as "West River," we see a delightful covered Burr truss bridge flanked by a pair of steel railroad bridges.

Covered bridges were quite common in New England where the severity of the winter could cause premature decay of a bridge's underpinnings. Many of these bridges were built without resort to nails, hardwood pegs being used instead. The decks of these

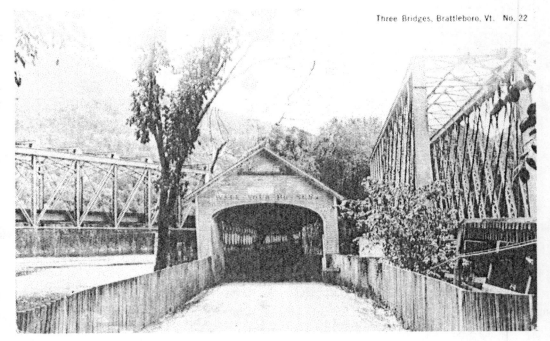

bridges were commonly constructed of loose laid planks seated only by gravity, hence the admonition to "Walk Your Horses."

The bridge on the left belonged to the Central Vermont, while the one on the right carried the West River Railroad, a shortline which was later absorbed by the Central Vermont. Today, sadly, the covered bridge is gone, as is the West River Railroad bridge, both victims of "progress." The bridge at the left, however, continues to carry the tracks of the Central Vermont.

VERMONT SHORTLINES

The Woodstock Railroad

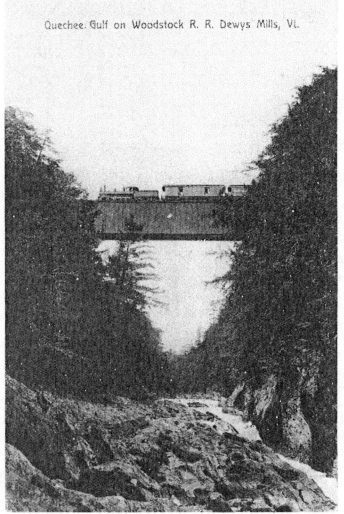

Quechee Gulf on Woodstock R. R. Dewys Mills, Vt.

The spectacular Quechee Gulf bridge was the high point of the 14-mile-long Woodstock Railroad. It was built in 1875, was 280 feet long, and 163 feet above the water. The view was sufficiently terrifying that for years the locals would tell of a whiskey drummer who begged the conductor to stop the train, saying he would rather walk across if only the train would wait for him on the other side. The conductor dutifully stopped the train on the other side, but the salesman signaled him to go on as he simply couldn't muster enough enough courage to cross the chasm on the bridge.

A steel bridge replaced the wooden span in 1911. The railroad served its communities well for 58 years, but was no match for the depression, and was abandoned in 1933. (Douglas Stamford collection)

The Hoosac Tunnel and Wilmington

Nestled alongside the Deerfield River, the Hoosac Tunnel and Wilmington Railroad presents a fascinating study in contrasts. It began as a narrow-gauge line with rails just three feet apart back

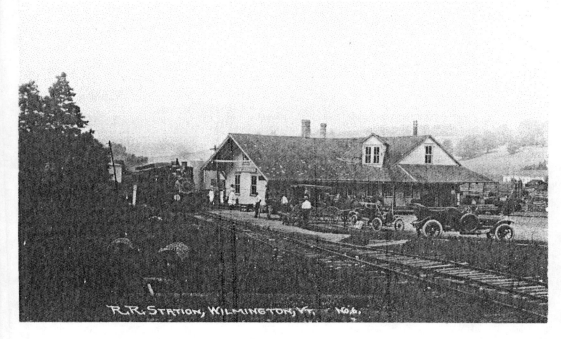

R. R. Station, Wilmington, Vt.

in the horse-and-buggy year of 1885 and was still running almost a century later serving a nuclear power plant. Back in the early narrow-gauge days arriving cars would have their trucks replaced so they could be delivered without the bother of having to transfer their cargo to narrow gauge cars. That required disconnecting the car's brakes. No problems were encountered until one day someone forgot to tighten some safety chains, and as luck would have it, two cars ran away with a brakeman riding down the mountain on cars with no brakes. Near the bottom the cars began to slow as they reached an uphill grade and the brakeman, sensing the ride was over, calmly stood and spun the disconnected brake wheel for the benefit of an admiring crowd in a convincing display of pure fakery which gained him several boxes of cigars as a reward. (Barbara Clark collection)

The BOSTON AND MAINE in Vermont

Connecticut Valley Line

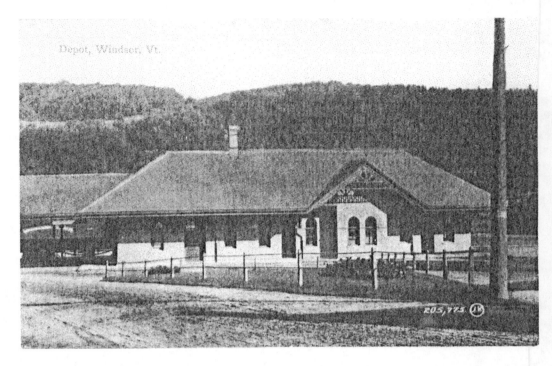

Depot, Windsor, Vt.

The Boston and Maine Railroad was incorporated on June 27, 1835. Curiously, it was not chartered in Boston, nor was it chartered in Maine, but rather it was a corporation of the state of New Hampshire. While it is true that the B&M did build a line from Boston across the Salmon Falls River and into Maine it can hardly be said that the name "Boston and Maine" really described the road. By the turn of the century the B&M had, through a process of lease, joint operating agreements and outright purchase, encircled the state of New Hampshire like a benevolent steel snake.

The 163-mile-long Connecticut Valley route up into Canada was constructed by many small roads which were finally welded into one under the auspices of the Boston and Maine. This line runs along the Connecticut River which is the borderline between New Hampshire and Vermont, sometimes on the Vermont side and sometimes crossing over to the New Hampshire bank. In the 1920's some of the northern part of the line was leased to and later sold to the Canadian Pacific under a joint operation agreement which gave the Boston and Maine rights to run over that part of the line.

Windsor, Vermont, is located about 12 miles south of White River Junction on the Boston and Maine's Connecticut Valley line. Just south of town the rails cross the Connecticut River on the four-span bridge shown here. The bridge was replaced during an upgrading of the line in the 1930's.

View from S. Main Street, Windsor, Vt.

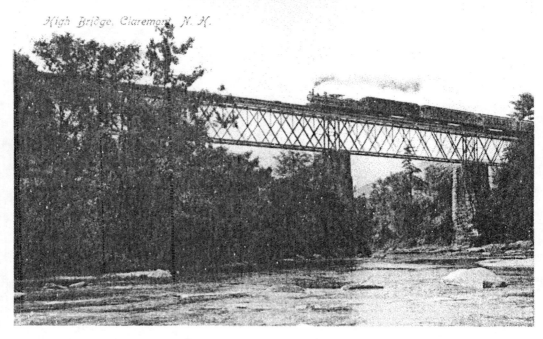

High Bridge, Claremont, N. H.

The Sullivan County Railroad was built in the middle 1850's to connect White River Junction, Vermont, with Bellows Falls. Of its 26 miles of main line, 25.19 were on the New Hampshire side of the Connecticut River. At various times the Sullivan County Road was leased to, operated over, or controlled by the Northern, the Connecticut Valley, the Boston and Maine, and the Central Vermont railroads, to name just a few.

In 1900 the Sullivan County boasted nine locomotives and some truly magnificent bridges. Here an American-type 4-4-0 is high-stepping across the spectacular High Bridge west of Claremont, New Hampshire, where the Sullivan had a connection with the Claremont and Concord Railroad. Within a few years the Sullivan County and the Claremont and Concord would both be gone, swallowed up by an expanding Boston and Maine.

As has already been described, White River Junction was an interchange point for many lines. The Boston and Maine ran north and south alongside the Connecticut River while the Central Vermont came diagonally across Vermont to reach White River Junction, as did the shortline Woodstock Railroad.

The Boston and Maine had another route reaching White River Junction from the east, the former Northern Railroad Route which crossed the Connecticut River on the four-span steel deck truss bridge seen on this rare postcard. The Northern Railroad connection was an important bridge route between the Atlantic Coast and Canada, as it was blessed with both modest grades and a direct routing.

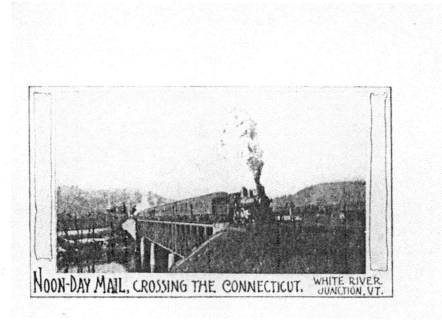

NOON-DAY MAIL, CROSSING THE CONNECTICUT. WHITE RIVER JUNCTION, VT.

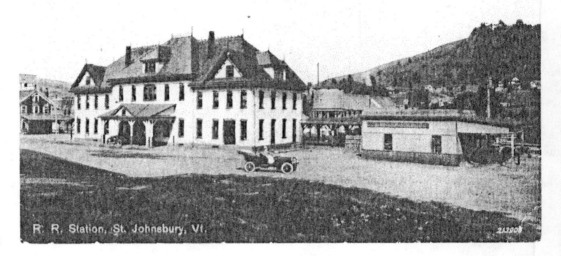

R. R. Station, St. Johnsbury, Vt.

The steel rails first reached St. Johnsbury in November of 1850, when the Connecticut and Passumpsic River Railroad puffed into town from White River Junction. During the course of consolidation the C&P became a part of the Boston and Maine. The trackage north of Wells River was leased by the B&M to the Canadian Pacific which eventually bought the track outright in 1926. St. Johnsbury is still an important junction with the St. Johnsbury and Lamoille County Railroad.

The station at St. Johnsbury was an imposing two-story affair with a steeply pitched roof pierced by innumerable dormers and topped with an icing of gingerbread trim. The boarding platforms were covered by a sturdy roof and a freight house stood ready close at hand for express shipments. Local freight tracks were adjacent to the depot so local merchants needed but few steps to retrieve their goods from the waiting cars.

Today the depot remains, used for retail stores. The passenger tracks are gone, but the freight tracks beyond are still in use.

One notable early-day resident of St. Johnsbury was Thaddeus Fairbanks, the inventor of the famous platform scale which bears his name. He established a scale factory there and, although 92 years of age, was on hand to turn the first spade of earth on the northward extension of the railroad toward Lennoxville, Quebec, in 1869.

In the 1890's Chicago businessman A. V. H. Carpenter recalled an amusing story about working on the early-day Passumpsic River Railroad as a brakeman. On a cold wintry night he was working on a stock train bound for Boston and while scrambling

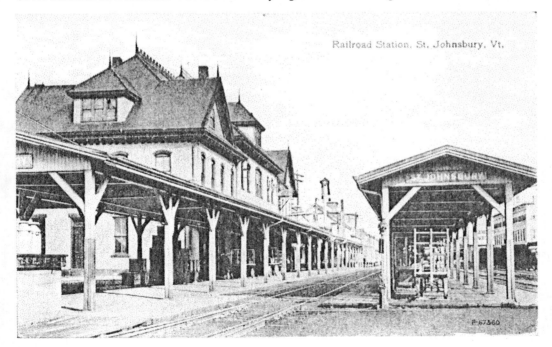

Railroad Station, St. Johnsbury, Vt.

across the car tops setting the brakes by hand he lost his lantern over the side, and in the ensuing darkness slipped off the roofwalk. Early stock cars did not have slatted sides, depending instead on rooftop hatches which could be turned back to provide ventilation for the livestock inside. As luck would have it, the unfortunate man tumbled through an open ventilator down into the car where he was nearly trampled underfoot by the cattle before being rescued at St. Johnsbury. It was an experience he enjoyed recalling for the rest of his life, and especially after he became a member of the Chicago Stock Exchange.

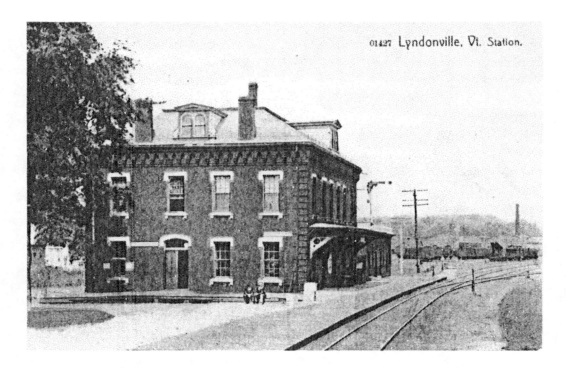

About nine miles north of St. Johnsbury is Lyndonville, Vermont. Then, as today, Lyndonville was another of those pleasant tree-shaded New England villages which, despite the world around them, never seem to change. Lyndonville was served by this sturdy two-story brick station with an attic and some of the most elaborate cornicework seen anywhere.

Close by the Lyndonville depot the Boston and Maine had a railroad shop complex where at the turn of the century railroad cabooses were built, and the equipment used on the Ompompanoosuc Division was serviced and maintained. This glimpse of the shops is sure to delight any antiquarian rail fan — not only are the foundry, pattern shop, machine shop and casting house clearly visible, clustered around the tall smokestack, but also such little details as a string of Burro cranes and the all-important wheel track where spare wheels were stored until needed are all there to be seen. The caboose shown on page 53 is of a class which was built in the Lyndonville shops in the 1890's.

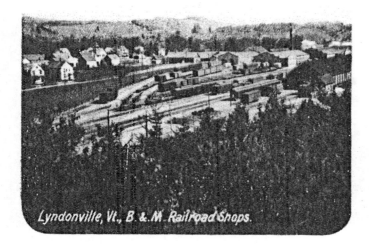

Lyndonville, Vt., B & M Railroad Shops.

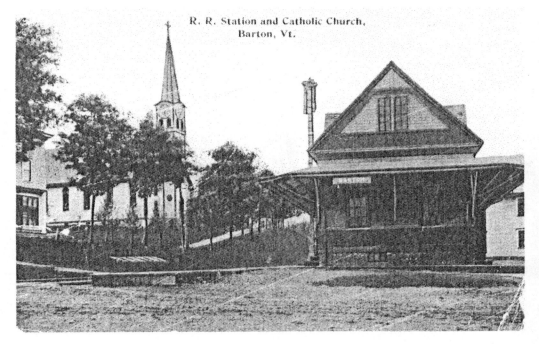

R. R. Station and Catholic Church,
Barton, Vt.

Barton, Vermont, is about halfway between Lyndonville and the Canadian border. It is yet another of those unchanging New England villages where the tall church spires contrast against the evergreen trees and the hardwoods turn to brilliant hues of color with the approach of colder weather. A tidy clapboard depot with a scalloped-shingle second story served the town, whose name was spelled out in whitewashed stones on the enbankment across the tracks from the station. Logging was big business there in days gone by and is still carried out today, although on a much smaller scale.

•

Four miles north of Barton is the even smaller town which was once known as Barton Landing. It was miles from any major body of water, and even today the locals can't explain what it was that Barton landed there. This card was postmarked in 1907, a few years before the town changed its name to Orleans, as reflected in the two views on the facing page.

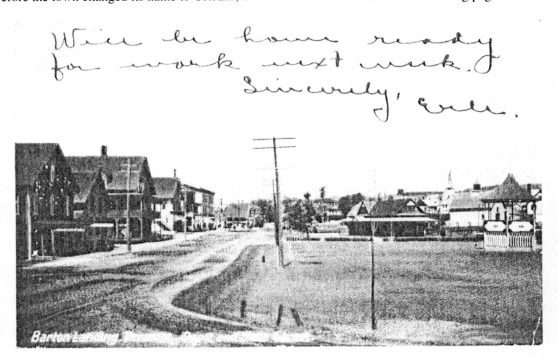

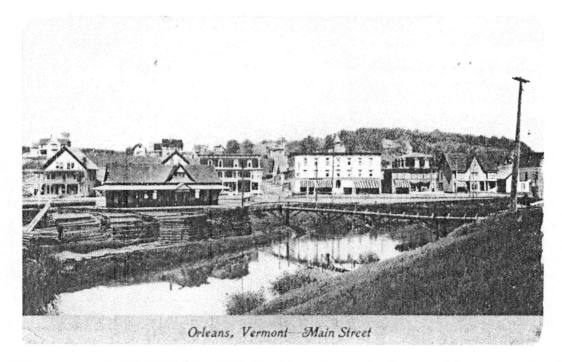

Orleans, Vermont— Main Street

This view which was postmarked in 1916 looks at Main Street from the opposite direction of the view reproduced on the facing page. It is interesting to note that while the name has been changed on the postcard, the letterboards on the station still read Barton Landing.

The predominant industry in the region was lumbering. The varied hardwoods which abound and make the New England foliage so colorful were also prized for the construction of pianos, which utilize a number of different hardwoods. A large piano back factory (a "piano back" is a major part of the instrument, consisting of a heavy wooden frame which supports a wooden diaphragm, called a "soundboard" which in turn is generally made of spruce) had its own siding track located across the stream behind the depot. No doubt the large stacks of lumber drying alongside the stream will soon be involved in making sweet music. While pianos are no longer made there the factory is still in use today, producing fine furniture with the brand name Ethan Allen.

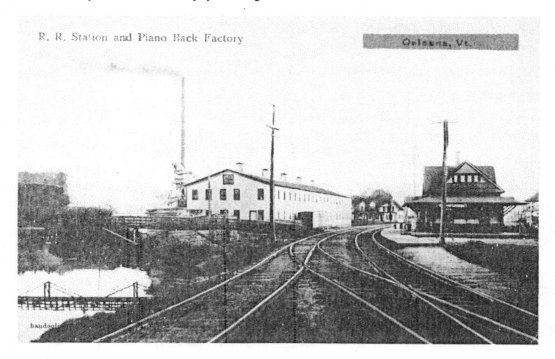

R. R. Station and Piano Back Factory Orleans, Vt.

Here we can see one of the popular sidewheel steamers alongside the wharf just beyond the station at Newport, perhaps waiting to take passengers to the Memphremagog House — a popular lakefront hotel which burned in 1907, the same year this card was mailed.

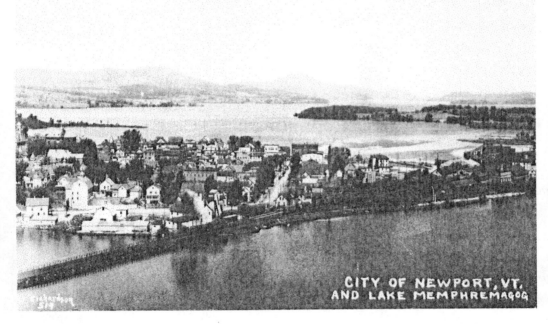

STATION AND STEAMBOAT LANDING, NEWPORT, VT.
PUB BY DAVIS & LIVINGSTON NEWPORT, VT.

Steamboat excursions on the 24-mile-long lake were quite popular in the 1880's and 1890's and the railroads often organized special outings which included transportation to and from the docks. This steamer features a walking beam, visible between the smokestacks. The "walking beam" system provides a way for part of the ship's propulsion machinery to be located outside, thus saving valuable interior space. In operation, the walking beam can give the impression that a giant grasshopper is hard at work inside, powering the boat!

At Newport, Vermont, five miles below the Canadian border, the Canadian Pacific loops down out of Canada, to swing around the southern tip of Lake Memphremagog. To the right in this view is the Boston and Maine's line running to Lennoxville, Quebec, (later to become the Quebec Central), and to the left is the Canadian Pacific line to Farnham.

In this view much of the city and lake can be seen. Although the wharf has lost its passenger shelter, the station can still be seen at the right, alongside the freight yard. A switch engine is hard at work in the foreground, near the local coal dealer's establishment.

CITY OF NEWPORT, VT.
AND LAKE MEMPHREMAGOG

BOSTON AND MAINE in New Hampshire

White Mountains Division

At the height of the Boston and Maine's activity, Wells River was one of the most important interchange points on the system. The B&M's own Connecticut Valley line ran through town while from the north the Canadian Pacific came into town, and the Montpelier and Wells River ran in from the west. On the New Hampshire side of the Connecticut River the B&M's former Boston, Concord, and Montreal line ended in Woodsville which was also the starting point for the White Mountains Division. The main interchange yards were in Woodsville along with a 20-stall enginehouse for servicing locomotives. The impressive three-story depot did double duty, serving as the headquarters of the White Mountains Division, as the line east from Woodsville was known.

Boston & Maine Station, Woodsville, N. H.

This steel bridge between Wells River, Vermont, and Woodsville, New Hampshire, replaced an earlier wood bridge built by the Boston, Concord, and Montreal in 1853. The original was a curious enclosed Burr Truss deck bridge design which cost the substantial sum of $20,000 to build. That bridge had four twelve-pane windows equally spaced along each side, to admit light into the lower level. The Boston, Concord and Montreal, which was always hard up for cash, opened the lower level to serve as a toll bridge for wagons, thus getting a little extra from their investment.

The Boston and Maine

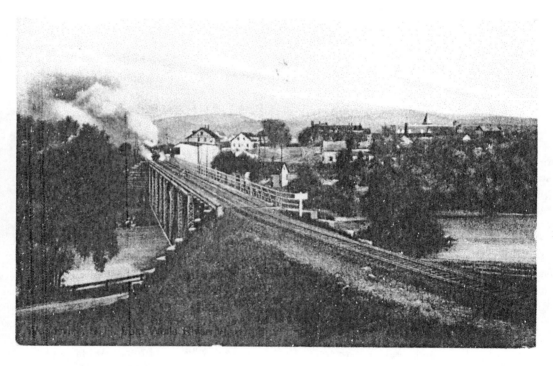

leased the BC&M in 1895, and replaced the 42-year-old bridge with a new one just eight years later, in 1903. Each end of that bridge was guarded with a large white sign announcing that trespassers on the structure would be fined the sum of $20.00, a large sum in that day.

The White Mountains Railroad, building north-eastward from Woodsville, New Hampshire, arrived in Littleton in 1853. The road's purse was so empty that it could not afford to buy its own locomotives, and began service using cast-off locomotives rented from neighboring roads. One of the early engines was a machine from Vermont's Passumpsic River Railroad that was called simply *Boy* and had scarcely enough power to pull the lightest trains up the grades.

RAILROAD STATION, LITTLETON, N. H.

Littleton was also the home of Sylvester Marsh, an eccentric inventor who had made a fortune in the formative days of the Chicago meat-packing industry before retiring to his native New Hampshire in the 1850's. He achieved fame for his railway to the peak of Mount Washington (see p. 58).

In time the White Mountains Railroad sought refuge under the protective wing of the nearby Boston, Concord, and Montreal which in turn was leased to the Boston and Maine system in 1895. The ornate depot shown here was used until the 1920's when it was replaced by a brick station which is still standing today.

The White Mountains were the center of New Hampshire's 19th-century tourist resort region and Maplewood's gingerbread-laden depot was located in the heart of the White Mountains. Surrounded by forests of pines and maples, these resort towns were advertised in elaborate books filled with woodcuts of mountain and lake scenes showing happy rusticators, as the tourists were known, and featuring alluring titles like "Summer Saunterings."

Surrounding Maplewood were some of the most famous resort hotels in New England, some with names which have come down to us today. Among the most famous were Crawford House, served by the Maine Central; the Summit House atop Mount Washington; the Pemigewasset House; and the Profile House, which had its own narrow

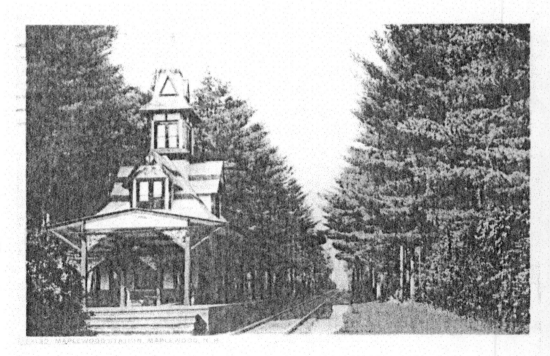

MAPLEWOOD STATION, MAPLEWOOD, N. H.

gauge railroad. All of these were reached in those pre-motorized days by steel rails that ran practically right up to the hotel doors.

Today most of these grand old hotels are gone, as are many of the depots which served them. Maplewood's depot was still standing, abandoned and completely overgrown, as recently as 1990 — surrounded appropriately enough by a dense growth of oaks and maples.

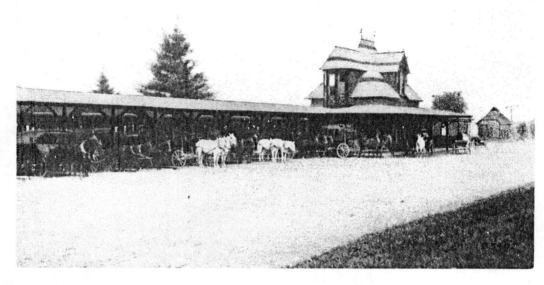

The tiny community of Bethlehem, New Hampshire, was served by this unique little depot which featured an incredible assortment of roof peaks and angles typical of the ornate designs common in the tourist areas of the day. Bethlehem was touted in early advertisements as a refuge for hay-fever sufferers, many of which were published by the railroad which operated through Bethlehem.

One of the chief publicists for the area was Edward Everett, one of the most distinguished orators and writers of the day. Although he is nearly forgotten today, he was so well known in the middle of the nineteenth century that it was he, and not President Abraham Lincoln, who was the featured speaker at Gettysburg. This depot still stands today, a private residence.

Bethlehem was also the terminal of the Profile and Franconia Notch Railroad, a thirteen-and-a-half-mile-long narrow-gauge short line which served a local hotel. Service began in 1879 with a pair of engines named *Echo* and *Profile* puffing back and forth each with a pair of varnished coaches on the drawbar. A later extension brought yet another tiny engine, shown here crossing Lafayette Brook, which operated back and forth along Bethlehem Street.

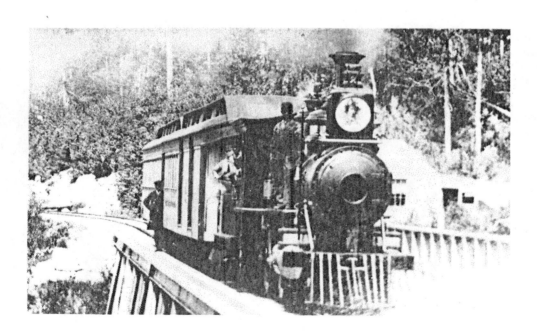

Boston, Concord and Montreal Route

The rambling Plymouth depot was located just below town. Its architecture was unique among Boston and Maine stations, appearing more like a fugitive from the American southwest than an inhabitant of New England. Plymouth was the junction point for the 23-mile-long Pemigewasset Valley branch to the mountain resort areas of North Woodstock and Lincoln.

Plymouth had its resort hotels as well. Close by the tracks at Plymouth was the Pemigewasset House, where the weary could find lodging and where the trains stopped to afford

B. & M. R. R. Station,
Plymouth, N. H.

famished passengers a chance to gulp down a hot dinner in the days before dining cars. Chicken pot pie was the house specialty, as it could be kept warm in the oven when the train was late. The hotel was owned partially by the railroad and had a convenient trackside location with a platform for easy boarding. The hotel burned in 1864 and was replaced by another house of the same name on High Street in the college district.

North Woodstock, nestled in the heart of the White Mountains, was reached by the 23-mile-long Pemigewasset Valley Railroad, as cited above. The Pemigewasset Valley line followed a northerly course from Plymouth, where it connected with the Boston, Concord, and Montreal. The rails followed generally along the course of the Pemigewasset River, eventually connecting with the East Branch and Lincoln, a busy logging railroad.

In the age of rustic hotels North Woodstock was not to be outdone by any of its famous neighbors near the station, and visible in the background of this view, is the Deer Park Hotel reached through the convenience of the hotel hack standing at the ready with a team of white chargers.

Today the North Woodstock depot is gone, torn down to make room for an interstate highway. All that remains is a portion of the station platform. The Deer Park Hotel is gone, too, its site usurped by a blight of condominiums, although an outbuilding remains in use as an office and sales room.

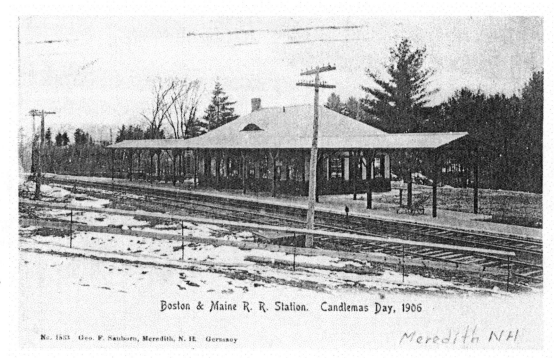

Boston & Maine R. R. Station. Candlemas Day, 1906

No. 1853 Geo. F. Sanborn, Meredith, N. H. Germany

Meredith NH

There was snow on the ground for Christmas in 1906, as this view of Meredith Station shows. Meredith was originally called Palmer Town, but the name was changed in 1768 to honor Sir William Meredith, a member of the British Parliament, who made many friends in the colonies when he spoke openly opposing King George's taxation policies.

While the freight house still stands, in use as the headquarters of a tree surgeon, the depot is gone, leaving only a few footings to mark its passing.

At The Weirs, the Boston, Concord and Montreal touched the western end of Lake Winipisogee, today called Winnepesaukee. The Weirs, which takes it name from Indian fish traps set in the lake in earlier times, became an important lake landing where freight and passengers would transfer to steamboats for delivery to the many resort camps and hotels in and around the lake.

From the 1850's until her retirement in 1893, the most popular steamboat on the lake

B. & M. R. R. STATION, THE WEIRS, LAKE WINNEPESAUKEE, N. H.

was the graceful 125-foot-long sidewheeler *Lady of the Lake*, operated by the Boston, Concord, and Montreal. Her open promenade deck stretched nearly the full length of the ship and was a delightful place to take in the view of the majestic White Mountains as the *Lady* cruised between The Weirs and Wolfeboro as the eastern end of the lake. When the Boston and Maine leased the BC&M the *Lady* was retired in favor of the B&M's own steamer, the *Mount Washington*. With her working days over, the *Lady* was scuttled in nearby Glendale Bay where her wreck remains an attraction to scuba divers.

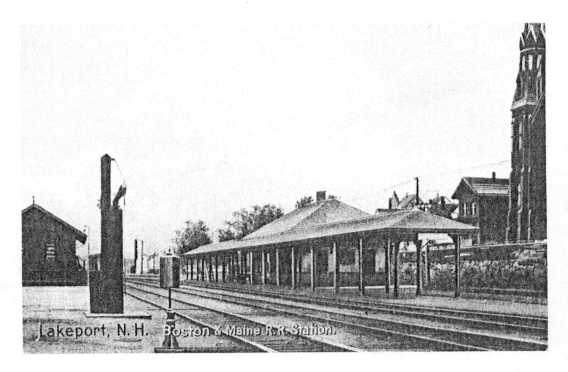

Lakeport, N.H. Boston & Maine R.R. Station.

The Paugus Bay trestle at Lakeport was the scene of the worst accident on the Boston, Concord and Montreal. In 1854 a special passenger train operating from the state fair at Laconia stopped on the trestle so the conductor could collect fares from those who were riding on the running boards and pilot of the locomotive. Suddenly another train appeared and crashed head on into the special. About a half dozen were killed and many more were injured in the wreck.

In the age of true craftsmanship New Hampshire craftsmen were renowned for their skills in woodworking. Concord was known for its stagecoaches, and the famed Concord Coach was a familiar sight both east and west in the days before motor cars. Laconia had a specialty, too — building railway passenger coaches. Many of the coaches which appear on these pages were products of the Laconia Car Manufacturing Company. The few which survive are marvelous examples of the carmaker's art. Typically, they were kept varnished and polished and, if they avoided the disasterous wrecks of the time, rolled grandly down through the decades as living symbols of that opulent age. The depot at Laconia was quite a bit more imposing than its neighbors, and unlike many survives to this day on an active line.

Passenger Station, Laconia, N. H.

Franklin is a typical New Hampshire mill village, located at the confluence of the Pemigewasset and Winnepesaukee Rivers. Fine seamless hosiery was a specialty at the mills which lined the steep-banked rivers. It was originally known as Pemigewasset Village, but the name was changed in 1820 to honor Benjamin Franklin. A local wag remarked at the time that since the names of all the Presidents had been used for naming the peaks of the nearby Presidential range that was the best they could do.

Franklin is one of those rare country towns which had no fewer than three depots at one time. The Northern

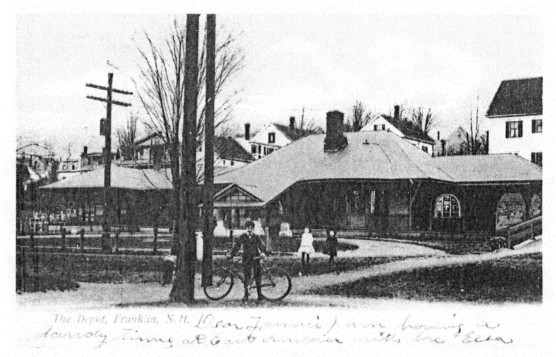

The Depot, Franklin, N. H. *Dear Jennie I am having a jolly time at East Franklin with the Ellis*

railroad passed though town and of course had to have a depot. The Boston, Concord and Montreal ran through nearby Tilton and soon a connecting line was built between the two main lines. The connecting route from Tilton linked up about 2 1/2 miles south of Franklin Station, so another station was built there and named Franklin Junction. To complete the confusion the connecting line ran close to the old mill village so yet another station was built there, and named Franklin Falls. The depot pictured here is the Franklin Falls depot. It was located high up on the wall of the river valley, with homes clustered both above and below, and was reached by a short street with the appropriate name of "Depot Road." Although the line remains active, the station is gone, torn down following the abandonment of passenger service on the line.

The village of Tilton was originally called Sanborntown Bridge. It was renamed Tilton partially in honor of a family of early industrialists who built a pioneer textile mill nearby, which took advantage of the bountiful supply of water power available there.

It is said that shortly after the Boston, Concord and Montreal was built through Sanborntown Bridge back in the 1850's a local farmer ambled up to the depot and asked the fare to a nearby town. When he was quoted what seemed to him to be too high a price, he asked what the fare would be if he were a pig. The fare for a pig was more in keeping with what the

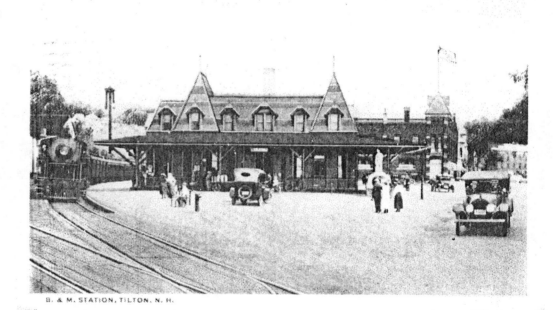

B. & M. STATION, TILTON, N. H.

farmer had in mind so he told the stationmaster to put him down as being a pig. History does not record if the farmer was made to ride in a stock car.

The striking little depot was built in 1882 at a cost of $6000, and served until the end of passenger service on the line in the early 1950's. It was dismantled in 1953.

Canterbury Depot. N. H.

Canterbury, just north of Concord, is one of those New Hampshire hill villages which time seems to have forgotten. It is perhaps best known for the colony of Shakers who settled there in the later years of the eighteenth century. While they were noted for their promotion of the doctrine of celibacy and for their peculiar worship which included clapping and dancing, they were also known as particularly industrious people. They constructed a reservoir and dam, dug a water power canal and built a grist mill where they ground not only their own grain but also that of their neighbors.

The tidy clapboard station shown in this turn-of-the-century view sat alongside of the grade crossing in the midst of the tall pine forests which blanket the area. Shortly after this postcard was issued a new station was built on the other side of the road and the old station was downgraded to a freight house.

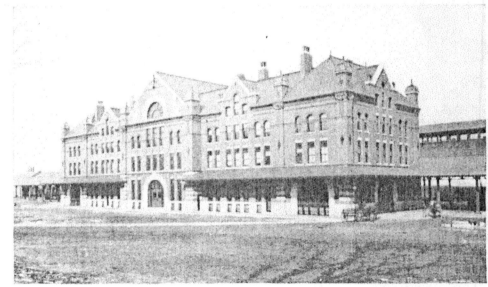

DEPOT. CONCORD. N. H.

Published by F. F. Nelson, Concord, N. H.

The rail scene at Concord was dominated by a large and impressive brick station, as befitted a state capital. The station was built in the 1880's at a cost of a quarter of a million dollars. The design was the work of Bradford Gilbert, who later became famous for his work on New York City's Grand Central Station.

Trains arrived from Boston traveling by way of Lowell and Lawrence. From Concord, tracks divided with one line going to Wells River, Vermont, over the old Concord and Montreal route, while a more southerly route headed for White River Junction to meet the Central Vermont on tracks laid by the Northern Railroad.

Concord, like so many railroad towns across New England, is a rail center no more. The passenger station was torn down in the early 1960's. The huge rail yard is gone, too. What remains of the shops are inhabited by typically unrailroadlike operations and rail service is freight only.

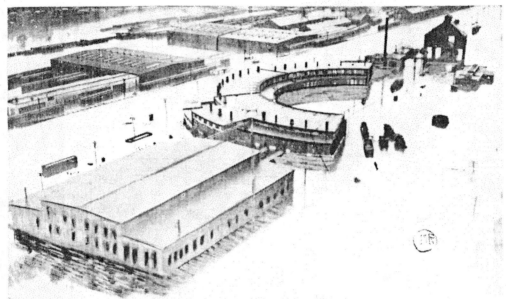

FLOOD SCENE. B & M ROUNDHOUSE AT CONCORD, N. H.

The Concord shops were the second largest on the Boston and Maine; only the North Billerica, Massachusetts, shops were larger. The shops shown here were built in 1897 and required enlargement just five years later. The shops alone covered over six acres. The freight yard was also jammed in between the Merrimack River and Main Street. The yard covered an additional 50 acres and kept over 100 men employed in 12 busy switch crews. Sometimes as many as 40,000 cars a month would pass through the Concord yard.

As is obvious from these scenes, the proximity of the yards to the Merrimack sometimes had drawbacks. The yard was flooded several times during the steam era; first in 1869, again in 1895 and 1927, and lastly in 1936.

In the upper view the repair shop is in the foreground and the semi-circular roundhouse is in the middle with the shops beyond.

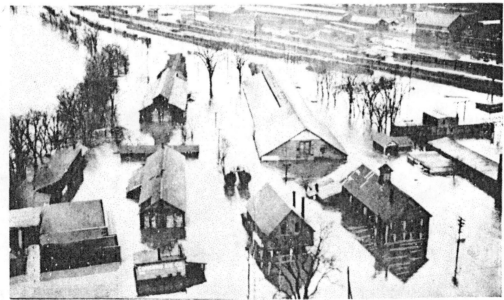

RAILROAD YARDS UNDER WATER AT CONCORD, N. H.

In 1810 the group of Boston textile mill industrialists who had built the city of Lowell, Massachusetts, cast about seeking a new location at which to surpass their former endeavors. They settled upon a small village about 18 miles southeast of Concord, New Hampshire, near the confluence of the Piscataquog and Merrimack rivers, a place called Amoskeag.

There they found a falls 55 feet high and a river which seemingly offered limitless water power potential. It would be the "Manchester of America,"

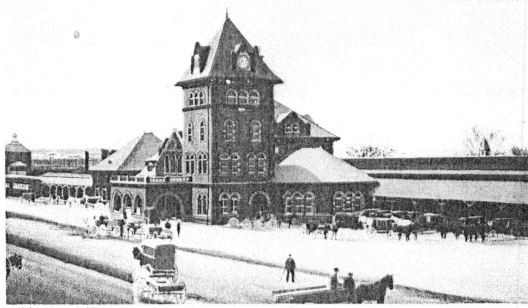

Manchester N.H. Railroad Station.

they said, comparing it to the great English manufacturing city of the same name. Canals were dug which diverted the power of the river through countless mill wheels.

At the height of passenger service Manchester's Union Station stood astride five routes which radiated out like the spokes of a giant wheel. From the south two main lines from Boston converged, one by way of Lowell and the other by way of Lawrence and Nashua. Down from the north came a main line from Concord while a connection to the Atlantic Ocean was made by way of Portsmouth. In addition to main line passenger movements, local traffic was so heavy that stub-ended tracks had to be installed behind the depot to accomodate locals; two big interlocking switch towers were required to control train movements in the area.

Amoskeag station at Manchester, New Hampshire, was built for the convenience of the Amoskeag Manufacturing Company. At its height the Amoskeag Company had the largest textile manufacturing plant in the world. The seemingly endless mills clattered with the pulse of 24,000 looms and 660,000 spindles, while the mills consumed 55 million pounds of cotton annually. After more than a century of operation the Amoskeag Company closed in 1929 as much a result of southern

Amoskeag Station, showing the Merrimac River, Manchester, N. H.

competition as in anticipation of the economic depression. After the closure portions of the mill were leased out and textile production continued although on an ever-decreasing scale, until today the New England textile industry has all but disappeared.

This fascinating view of the railroad yard at Manchester offers but a small idea of the scope of turn-of-the-century railroad operations. The textile industry was at its height. Yankee ingenuity was inventing and perfecting machines the likes of which had never been seen. The railroads were the undisputed king of long distance travel, and the only way to ship products to market.

In this view, Manchester's Union Station is at the left. In the center, above the diamond crossings, are the team tracks, so called because wagons drawn by teams of horses would load and unload

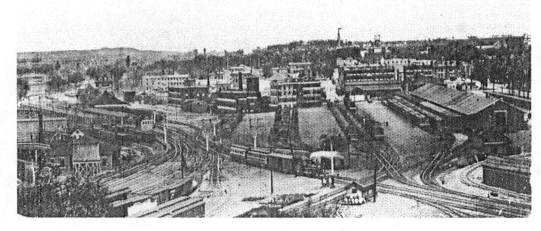

Bird's Eye View of B. & M. Railroad Yard, showing Freight Depot and Passenger Station, Manchester, N. H.

directly from the rail cars spotted there. At the right are the railroad's freight depots.

So much freight is in transit that the cars are doubled up for loading and unloading at the freight house. When needed, the switch crews would carefully spot the cars so that the doors of cars on adjacent tracks would be aligned. The freight handlers could load the second car without moving the first by the simple expedient of throwing some planks down between the cars.

Manchester's machine tool industry also had its beginnings in the Amoskeag Manufacturing Company. Originally the Manchester Machine Works was equipped to make and repair textile machinery for local textile factories. However, in 1849, they received the go-ahead to undertake manufacturing equipment for other concerns.

Some of the first products undertaken were steam boilers and engines, followed in the natural course of events by steam locomotives. It wasn't long before residents of nearby villages were often treated to the sight of a locomotive with some far-off

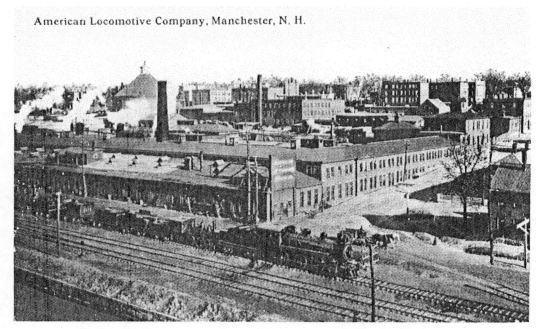

American Locomotive Company, Manchester, N. H.

road name rolling into town, the beaming smiles of the crew telling the tale of yet another satisfactory test run.

Shortly after the turn of the century the Manchester Locomotive Works became a part of the American Locomotive Company, also known as ALCO. Although this giant corporation continued to build locomotives well into the diesel era, like much of smokestack America it too has become just another memory.

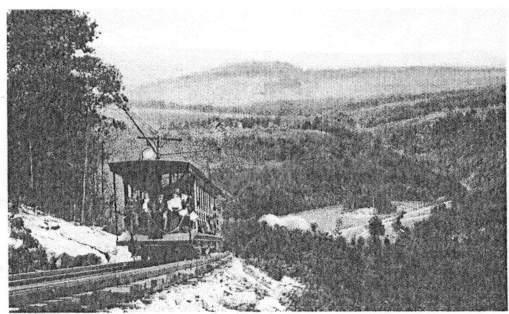

CAR DESCENDING UNCANOONUC MOUNTAIN, MANCHESTER, N. H.

At the turn of the century Manchester had first-rate electric trolley service provided by the local power company. One fascinating part of the service was a sightseeing line which climbed Mount Uncanoonuc, overlooking Manchester. A path was hacked out of the heavily wooded flank of the mountain, and trolley wire was strung overhead. The cars were curious open-air affairs, with their floors tilted in a step arrangement so that the seats would be more or less level while on the mountainside.

Scenic railways like this one were popular around the turn of the century although most have long succumbed to the financial realities of mass transportation. Service on this line was suspended during the depression, although the equipment was not scrapped until the 1940's.

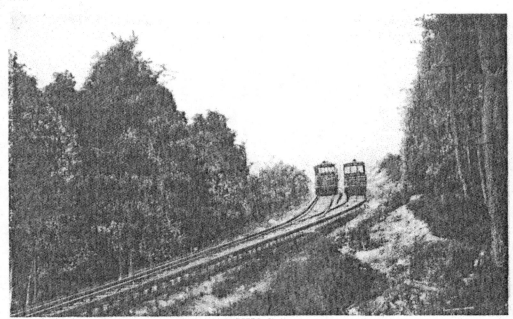

TURNOUT ON UNCANOONUC MOUNTAIN, MANCHESTER N. H.

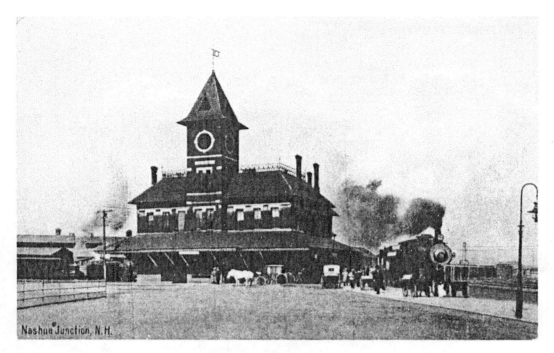

Nashua is in the southeastern corner of New Hampshire, astride the Boston, Concord and Montreal's route between Lowell, Massachusetts, and Manchester, New Hampshire. At the turn of the century Nashua was also the terminal of a main line which ran out Hollis Street on its way to Keene, crossing the state from east to west. Passengers could change cars there for many destinations spread across the lower part of the state. As befitted the importance of a major rail junction, this substantial brick station with a tall tower was erected, dominating the rail scene as is evident in this view postmarked in 1906.

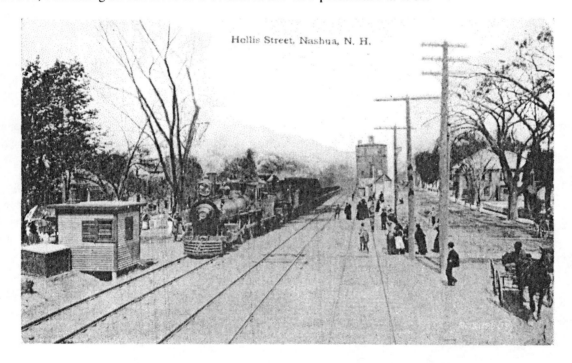

This view was snapped before the turn of the century as a doubleheaded freight rolled up Hollis Street into the city of Nashua. The picture is full of details of interest to die-hard rail buffs: On the point is a splendid American type 4-4-0 replete with a big box-like oil headlight. Note the unusual slatted pilot (to some readers, the term "cowcatcher" might sound more familiar), and the link-and-pin coupler bar — a hazardous device soon to be outlawed in favor of the automatic coupler. The second, or road engine, is a woodburner with a funnel-shaped spark arrester smokestack offering up a fine cloud of gray wood smoke. Yes — at this writing, tracks still run up Hollis Street, right through the heart of the city.

Northern Railroad Route

A telegrapher's transcription error in the early morning hours of September 15, 1907, resulted in one of the worst wrecks in the history of the Boston and Maine Railroad. In reporting that train 34, the eastbound *Montreal Flyer*, was running an hour late the number was accidentally changed to that of number 30, the eastbound *Quebec Express*. Armed with this misinformation, timetable

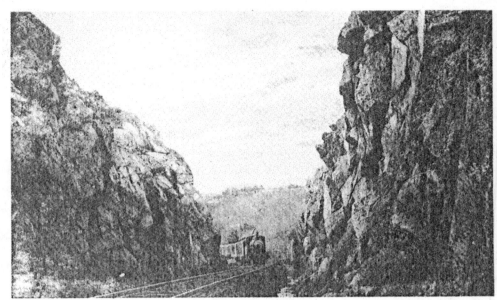

Orange Cut, Summit Siding, Canaan N H.

freight 267, waiting on a sidetrack at Canaan, New Hampshire, waiting to meet the *Quebec Express*, pulled out to move to West Canaan summit siding four miles further on.

The *Quebec Express*, running only about 30 minutes late, was loaded with fairgoers returning from Sherbrooke, Quebec, in the coaches as well as the usual number of Pullman cars. The happy group of excursionists had just begun singing when there came a terrible crash as the trains met head-on in the darkness. The baggage car behind the engine reared up and split open the following coach from end to end, coming to rest against the platform of the smoking car beyond. Twenty-five people were killed and another twenty-six were seriously injured.

As the survivors pulled the dead and injured from the wreck, the dazed conductor was found sitting on a railhead alongside the wrecked engines, still clutching the fatal dispatch in his hand. Out of the carnage a true railroad hero emerged, brakeman Frank Ryan. Although bleeding from a severed artery in his neck he alone remembered that the *Montreal Flyer* was bearing down on the wreck scene only minutes behind and he directed a man to run back down the track to stop the *Flyer*.

By only the narrowest of margins an even greater tragedy was averted, as the *Flyer* ground to a halt just a quarter mile from where it would have plowed into the wreckage.

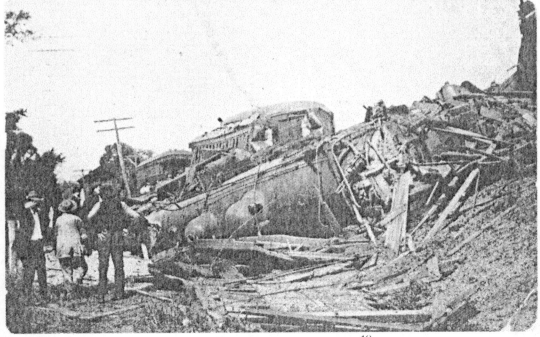

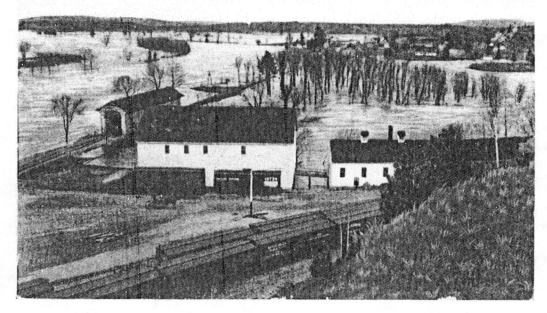

High Water at Penacook, N. H. April 15 Th 1895.

On Monday, April 15, 1895, a record-breaking flood descended down the Merrimack River upon Penacook and Concord. Two days of steady rains melted the remaining snowcover which quickly flowed into the Merrimack. Tragedy was narrowly averted when late in the afternoon an alert official of the local power company noticed the water was rising at a rate of about four inches per hour, and took it upon himself to sound an alarm to warn those in lowland areas near the river to evacuate to higher ground. Undoubtedly many lives were saved by this timely warning as the river topped its banks in the darkness of that fateful evening. (Barbara Clark collection)

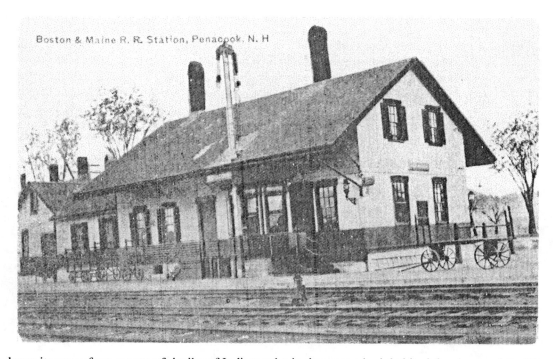

Boston & Maine R. R. Station, Penacook, N. H

Penacook draws its name from a powerful tribe of Indians who in days gone by inhabited the shores of the Merrimack River west of present-day Concord. They were led by their wise sachem, Tassacoonaway, a gentle giant who stood over six feet tall. He preferred the ways of peace to those of war, yet had forged an alliance of the local tribes to resist the aggressions of the warlike Mohawks which lasted until the tribe was ravaged by a plague which reduced them to a scattered handful of forlorn survivors.

Running out of nearby Concord, rail lines went through Penacook on both banks of the Merrimack River, the Northern Railroad route bound for White River Junction, and the Central Vermont and the Boston, Concord and Montreal route headed for Wells River and the Canadian Pacific further north. This attractive little bay-windowed station was on the Northern Railroad line.

Concord and Claremont Route

This attractive little hip-roofed brick station served Newport on the Boston and Maine's Claremont branch. The tracks were originally laid by the Concord and Claremont Railroad. The little road was chartered in the 1850's, but it wasn't until 1872 that service began on the line. A trip took over three hours and passed over more than 40 bridges, about 15 of which were of the covered variety, as it crossed and recrossed the Sugar, Warner, and Contoocook Rivers.

In later years the line regained its independence as the Claremont and Concord, but sadly, service was cut back in stages between 1964 and 1980. Newport, about 10 miles east of Claremont, was the end of the line when service was discontinued in 1979.

About midway on the 47-mile-long Claremont Branch was the Lake Sunapee Lake Station. Located where the rails curved around the southern tip of Lake Sunapee in the shadow of the mountain of the same name is a scene almost too pleasant to be true. Here the 101-foot steamboat *Armenia White* simmers at her pier awaiting another trainload of excursionists bound for cottages around the lake. Out of sight, except for her stack, is the *Kearsarge* whose name recalls the nearby mountain of the same name from whose slopes the timbers for the famed Civil War battlewagon, the *U. S. S. Kearsarge*, were felled.

The Lake Station was located at the summit of a stiff grade and trains in both directions often needed helper engines to surmount the hill. It was also the destination of many weekend and holiday excursion trains. Barely visible beyond the depot is a turntable used for turning helper and excursion engines. The *Armenia White* cruised the lake for three decades before being laid up in 1917. The *Kearsarge* was scrapped during the great depression.

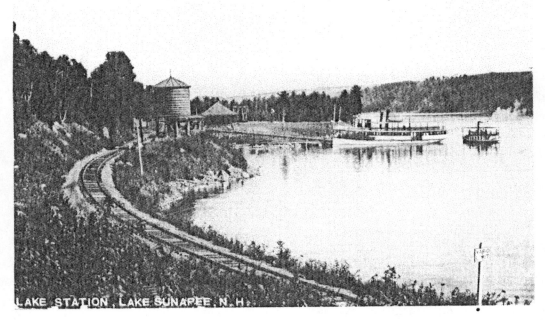

LAKE STATION, LAKE SUNAPEE, N.H.

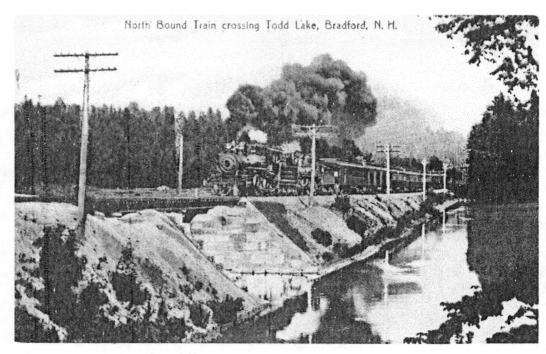

North Bound Train crossing Todd Lake, Bradford, N. H.

A few miles east of Lake Sunapee on the same Claremont branch, a double-header roars across Todd Lake near Bradford. The fast-stepping "American" type locomotives are spreading a goodly cloud of bituminous coal smoke as they hike seven cars of varnish over the road. Of the fifteen covered bridges on the line, surprisingly no less than four remained in service at the end of the Boston and Maine's steam era.

[Editor's note for non-railfans: train buffs refer to the smoothly-finished wooden passenger cars of that day as "varnish"; the usage here doesn't mean that the engines are pulling seven cars full of paint-factory products.]

New Boston Branch

This very unusual station served New Boston, New Hampshire, at the end of a Boston and Maine branch out of Manchester. The tower is perched atop the station agent's bay window office close by what must be the mother of all New England fireplaces, located in the end wall. Beyond the station is the freight house, adjacent to which is the ubiquitous water tank to which is fitted what must be the world's longest such spout. Service to New Boston ended in 1936, but the New Boston station is still serving its community as a station, although now the local constabulary calls it home.

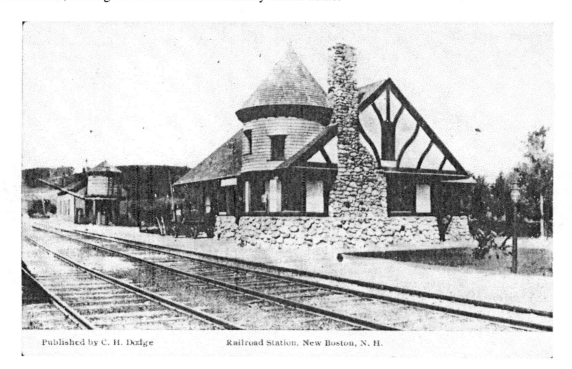

Published by C. H. Dodge Railroad Station, New Boston, N. H.

43

Contoocook Valley Route

The trestle at Hillsboro, New Hampshire, was destined to become one of the most beloved of photo spots for rail photographers at the close of the steam era. It was located on a main line between Worcester, Massachusetts, and Concord, originally built by the New Hampshire Central Railroad. From a connection with the Fitchburg Railroad at Peterboro the line ran north to Elmwood Junction, where it crossed a Nashua-to-Keene main line before going on to Hillsboro. Some years after

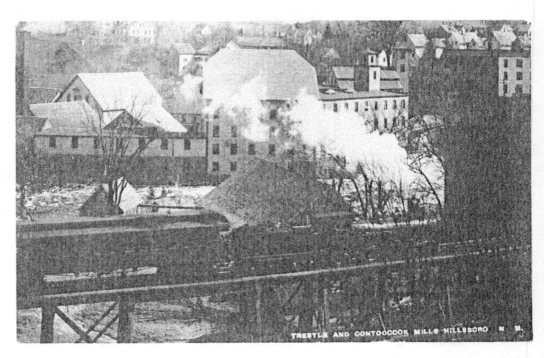

consolidation into the Boston and Maine the track from Hillsboro to Henniker was taken up after a bridge washed out. Later the track between Elmwood Junction, Keene, and Peterboro was put out of service and eventually pulled up.

This arrangement isolated Hillsboro at the end of 44 miles of the most bizarre branchline arrangements imaginable, until a connection was made in the 1950's. Trains bound for Hillsboro would head west from Nashua as far as Elmwood Junction where the train would seemingly turn south toward Worcester. Then the train would back up, pushing its cars ahead of it, until it had passed the switch to Hillsboro. Pointed once again in the right direction, the train would then puff off on its way.

Fortune smiled on the Hancock High School basketball team on February 22, 1922. While they never made it to Contoocook for their game, they all escaped serious injury when the 3:10 afternoon train from Peterborough went into the ditch about a half mile west of Antrim.

There was no warning of danger as the engineer began to brake for his scheduled station stop, but just as he applied the brake the coaches lurched to the ties, then wrenched themselves free from the engine and rolled down a 20 foot embankment and

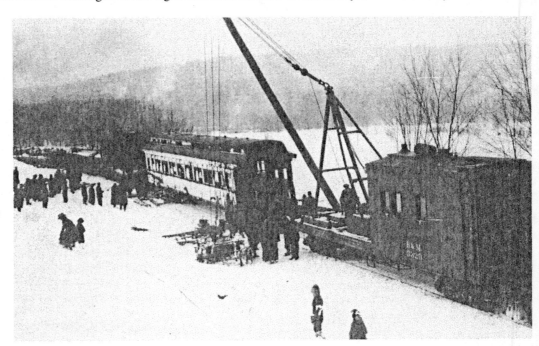

came to rest on their sides in the snow. Fortunately none of the 25 persons aboard were killed but there were plenty of bruises to go around.

The view shows a wrecked coach just as it has been hauled back up the bank with the assistance of a pair of cranes. Note that the snow is still plastered on the car from where it had come to rest on its side. Investigators speculated that a wheel or flange had cracked in the cold and then broken free as the brakes were applied, causing the wreck.

Fitchburg Railroad Routes

Walpole is located on a former Fitchburg Railroad line which linked Bellows Falls, Vermont, and Fitchburg, Massachusetts, by way of Keene, New Hampshire. The pastoral setting pictured here with the neat little station offered quite a contrast to the bustle just a few miles away at North Walpole, where the B&M had a major yard for interchange traffic with the Connecticut Valley Line, the Rutland, and the Central Vermont.

Published by A. P. Davis, Walpole, N. H. Boston & Maine Station, Walpole, N. H. *Alex. Davenport*

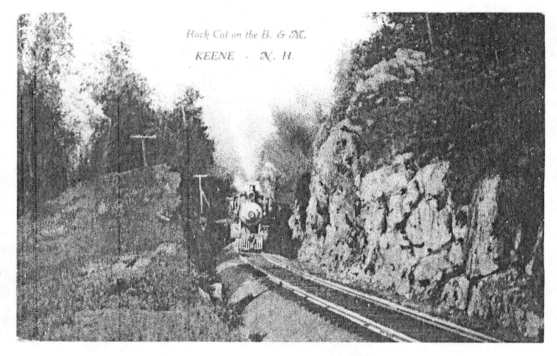

Rock Cut on the B. & M.
KEENE - N. H.

On August 22, 1900 a freak accident occurred near Keene. A local freight working on the former Fitchburg Railroad line just south of Keene dropped off three cars at a siding where a gravel train was engaged in making some repairs. Since the gravel train was working on the main and the local was on the passing track it was necessary to spot the cars on the main behind the gravel train.

After the local had left, the gravel train coupled onto the three cars for some unknown reason and shuffled back and forth for some time in the performance of their work with the three cars attached to the work train. Suddenly the foreman of the gravel train noticed that the three cars were no longer attached to the train, but rather they were picking up speed as they headed out of town on their own. The engine from the gravel train started in pursuit but it was hopeless to try and catch up.

Meanwhile express passenger train No. 517 was streaking toward Keene on its way to Bellows Falls at the rate of forty-five miles per hour when it met up with the fugitives. The engine crashed through the first two cars which were empty, but the third was full of gravel. The express engine was thrown from the track, the engineer sent to glory, his fireman badly hurt and the passengers bounced about quite a bit.

In the investigation which followed the brakeman said the conductor had coupled the cars to the work train. The conductor said that he had been busy with some paperwork and hadn't done the deed. The engineer said that he believed that the cars had coupled automatically when the locomotive backed into them. Understandably the railroad commissioners were less than impressed with these explanations and said that regardless of who coupled the cars it was a complete lack of attention which caused the accident.

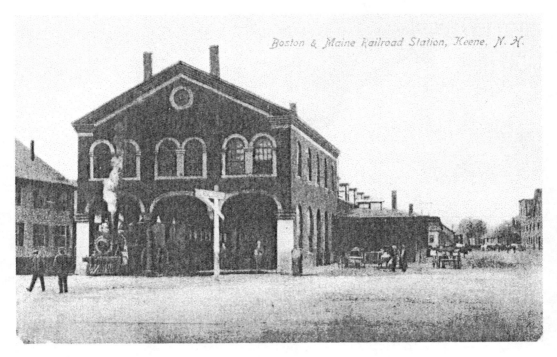

Boston & Maine Railroad Station, Keene, N. H.

Keene was another major junction point on the Boston and Maine. Located in the southwest corner of New Hampshire, Keene sat astride four routes. There was an east-to-west main line between Keene and Nashua in the southeast corner of New Hampshire; from the south came a pair of former Fitchburg Railroad lines, one from Fitchburg itself and the other coming from Greenfield, Massachusetts. Off to the northwest the railroad town of Bellows Falls beckoned and dutifully a line between Keene and that important junction community was also built.

In the early years Keene featured a covered station, as seen here, wherein the tracks ran directly into the building so that passengers could board and alight in comfort in all seasons and eventualities of the weather. The handsome building covered three tracks, and featured graceful arch-topped windows and some rather beautiful cornice work. It's reasonable to assume that there was discomfort to the occupants of the second floor when they let windows over the tracks be open when locomotives passed underneath!

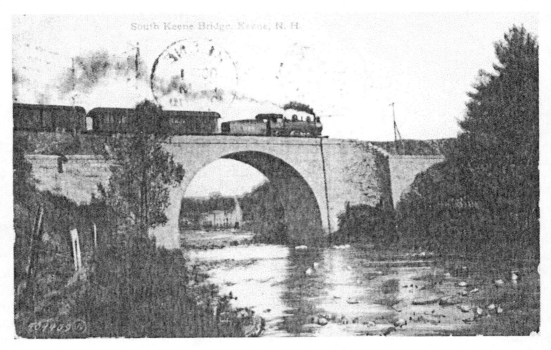

South Keene Bridge, Keene, N. H.

A somewhat chunky American type 4-4-0 heads up this passenger run crossing the South Keene bridge. Although all rail service into Keene ceased in the 1980's this graceful rustic stone arch still bridges the shallow stream just as it did in 1910 when this card was mailed.

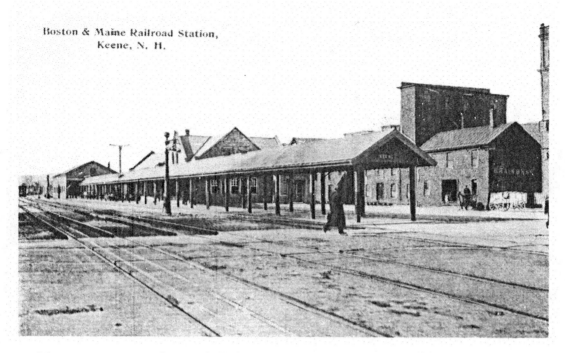

Boston & Maine Railroad Station,
Keene, N. H.

After the turn of the century a new station was built for Keene. The new station, shown in the upper card which was postmarked in 1917, featured a more conventional canopied platform capable of accomodating the longer trains which were coming into use at the time. Note that the primitive American type 4-4-0 locomotive in the previous page has been replaced by a much larger and more powerful Pacific type 4-6-2 in the later, lower card here.

This view provides the reader with a vignette of life seldom found in the seemingly sanitized typical postcards of the era, and it gives one something of that "down-by-the-tracks" feeling. A sign on a building in the background announces the presence of the E. J. Colony Chair Company. The wagon waiting by the engine proclaims itself a carrier of baggage and express, and best of all, there's not an automobile in sight! In a situation repeated over and over again in New England, today Keene, once a major rail junction point, is without rail service of any kind, the last line into the city having been abandoned in 1983.

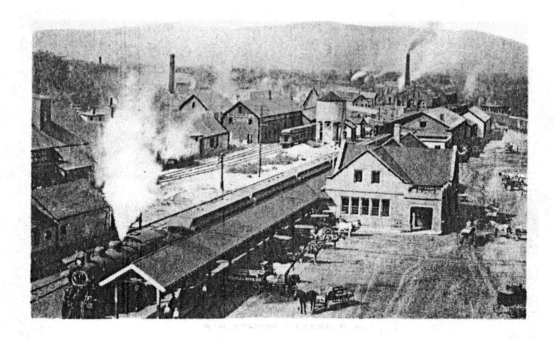

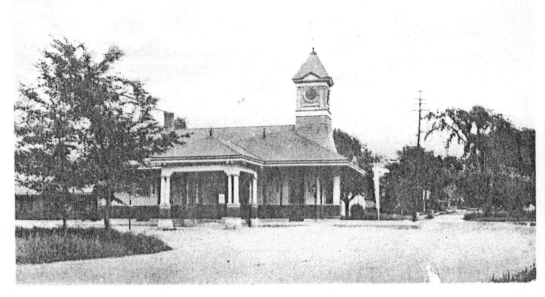

The little mill village of Milford is located west of Nashua. From Nashua the rails follow the course of the shallow Souhegan River to Milford where, just below the waterfall that once powered a grist mill, there was a shallow water crossing which gave the village its name.

East of town the tracks split, with one leg going west to Keene, while the former Fitchburg Railroad line dips down to go to Ayer, Massachusetts. Each line had its own station; the Fitchburg road's, seen here, had a handsome cupola topped by a weathervane. The station still stands at this writing, and houses a beauty parlor.

Lakes and Coastal Region

HARNE'S POND, DERRY, N. H.

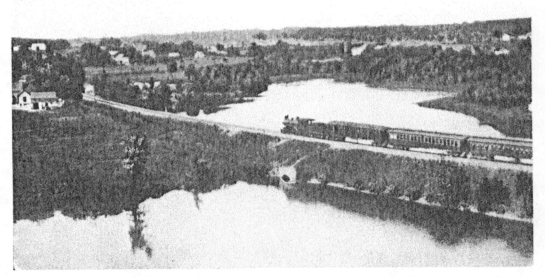

Harne's Pond near Derry, New Hampshire, was located on the Boston and Maine's main line between Manchester and Lawrence, Massachusetts. Unlike the mountainous northern part of the state, the area around Derry is a charming rolling country of meadows and forests. This picture shows the way it was back in 1909, when the American type 4-4-0 reigned supreme on the rails and life's pace was a bit more leisurely that it is today. In the original photograph from which this postcard was made the baggagemaster can be seen taking in a bit of fresh air at the open door of the car. Today the iron horse no longer crosses Harne's Pond; service was discontinued on the line in 1986.

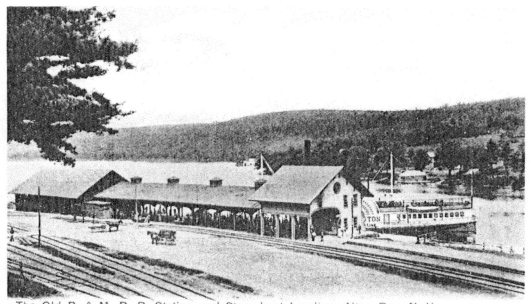

The Old B. & M. R. R. Station and Steamboat Landing, Alton Bay, N. H.

Destroyed by fire Nov. 4, 1906.

The Boston and Maine was a study in contrasts. Across Massachusetts, the B&M was the racetrack of New England with the former Fitchburg RR main line taking a bee line between Troy, New York, and Boston through the famous Hoosac Tunnel. At the same time the Boston and Maine employed track throughout New Hampshire which, it could be said with no small exaggeration, went from nowhere of consequence to nowhere in particular. One such line was the arm which encircled the southern shore of Lake Winnepesaukee, connecting Lakeport with Rockingham. Although scenic, the line was never particularly successful and was abandoned in stages beginning in 1936.

One of the high points of this line was the station stop at Alton Bay, located roughly midway along the line. There was a beautiful depot built right at the water's edge permitting passengers to step directly aboard the beautiful sidewheel lake steamer *Mount Washington,* shown docking in this turn-of-the-century view. Sadly, that depot was destroyed completely in a fire in November of 1906; a new depot was built just up the hill as seen in the lower view. The reader may note that the lower view is taken from the steamboat landing, the original depot having been located about where the stack of pilings are in this 1916 scene.

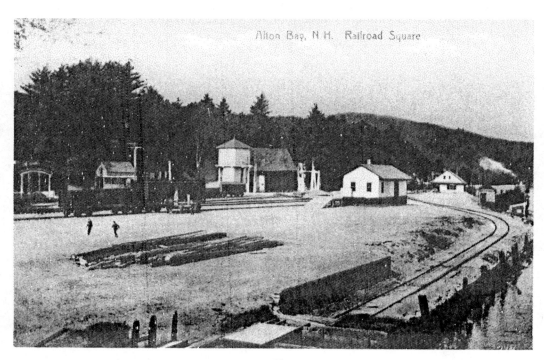

Alton Bay, N. H. Railroad Square

49

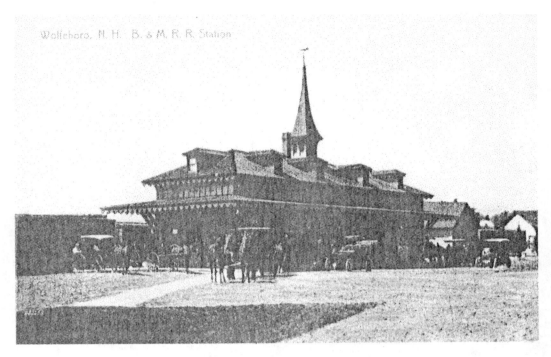

Wolfeboro, N. H. B. & M. R. R. Station

Wolfeboro, located at the northeast corner of Lake Winnepesaukee, is one of the few villages which could boast two railway stations. One was located in town and the other right out on the steamboat landing, where travelers could change directly from the cars to one of the many steamers which plied the lake delivering passengers, freight and mail to the lakeside hotels, camps, and villages.

Wolfeboro was reached by means of a short branch off the B&M's North Conway line, a road originating at Dover, New Hampshire, and running up to meet the Maine Central at North Conway. After service was discontinued on the Wolfeboro branch, the station was stripped of its ornamentation only to have it restored when the Wolfeboro Railroad — a combination tourist and freight hauling endeavor started in the late 1970's — began operation. After the Wolfeboro Railroad was abandoned in 1986 the roof was damaged in a fire; thankfully, repairs have since been made, and the depot is once again at the time of this writing in pristine condition.

The station at the steamer landing survives as well. Today it is still involved in tourist activity, housing a business which serves ice cream to waterfront patrons.

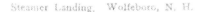

Steamer Landing, Wolfeboro, N. H.

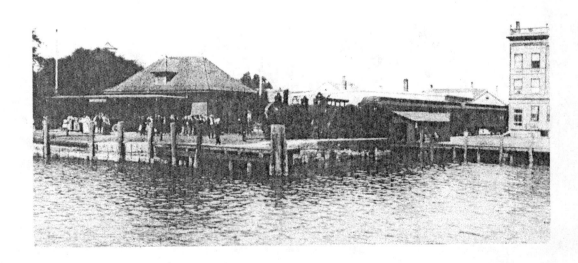

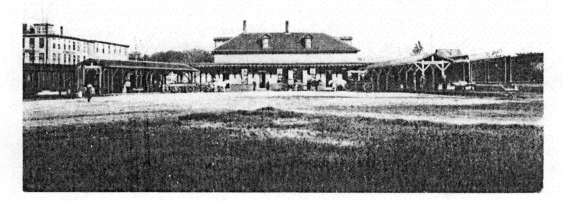

Rochester is located on the Boston and Maine's branch between North Conway and Dover. In addition to serving traffic on the North Conway branch it was the terminal for a line which ran to Lakeport, skirting the southern shore of Lake Winnepesaukee, and terminal for the Boston and Maine's inland route to Portland, Maine. The station was a very busy place and often trains would be serviced on both sides of the depot at the same time.

As would be expected, regulating traffic into the station was quite a job with three lines entering from different directions. Clearance was controlled by an unusual two-masted ball signal whose operator raised lighted globes to the top of a mast. The number of globes displayed signalled whether or not trains had permission to enter the station.

Rochester was the scene of a most unusual accident in 1900. It seems that one Warren Foss was taking some stock to market in Boston on February 21st aboard a train which stopped on a siding near the station. While he was throwing some baled hay to his animals, the 2:30 passenger train was leaving the station. When the engineer whistled for a nearby crossing Foss put down the bale of hay he was carrying and stepped back to watch the train go by. Unfortunately the step of the first car in the train caught a corner of the hay bale and kicked it into the air, striking the man with such force that he fell against the moving train and was instantly killed.

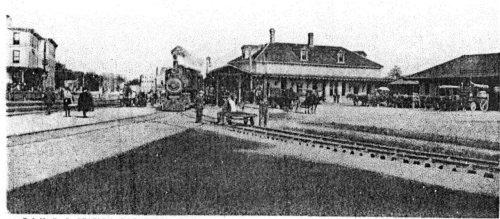

B & M R. R. STATION ROCHESTER N. H.

Dover was located on the original Boston and Maine main line between Lawrence, Massachusetts, and Portland, Maine, and boasted this fine brick depot, generally similar to the one at nearby Rochester.

In the early days of railroading, competing lines were built between Boston and Portland. The tracks of the Eastern Railroad ran right along the coast through Portsmouth, while the Boston and Maine laid tracks along an inland route by way of Lawrence, Massachusetts, before turning northeast toward Dover and Portland.

At Dover Junction, just north of the village, the North Conway branch left the B&M to run up to its connection with the Maine Central. After service on the North Conway branch ended in 1972, the rails were not removed, and at this writing the southern portion of that branch sees service with the gravel trains of the New Hampshire Northcoast working between Dover and Sanbornville.

Portsmouth, New Hampshire, at its Atlantic Coast location was a logical target for early railroad promoters building lines from Massachusetts. It was first reached by the Eastern Railroad, which was built up the coastline from Salem, arriving on the last day of December 1840.

At least one early resident was not pleased by the appearance of the railroad in his home town.

In 1893 Thomas Aldrich recalled the event in his book *An Old Town by the Sea*, "The running of the first train over the Eastern Road from Boston to Portsmouth . . . was attended by serious

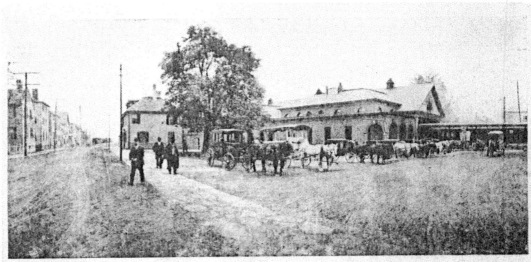

B. & M. Railway Station, Portsmouth, N. H.

accident . . . This initial train . . . ran over and killed . . . LOCAL CHARACTER . . . The last of the cocked hats (have) gone out — the railway has come in!"

Arriving some years later, the Boston and Maine came in from the west by way of Rockingham, 10 miles away. Eventually the Eastern Railroad became a part of the Boston and Maine, but the duplicate lines into Portsmouth continue to be operated to this day.

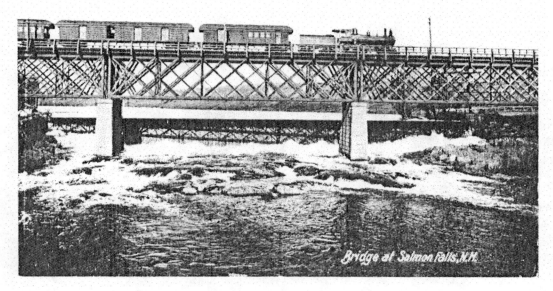

Led by a classic American type 4-4-0, a Boston and Maine mail train chuffs across the steel Salmon Falls River bridge at the border between New Hampshire and Maine in this early 1900's view. The bridge over the Salmon River was located on the original Boston to Portland, Maine, route of the Boston and Maine. Directly behind the locomotive is an early Railway Post Office car where mail was sorted by postal clerks while the train was underway. The device at the small door of the RPO is a mail arm for picking up mail at stations where the train does not stop. Behind the RPO is a unique eight-door car where it appears that the baggage master is enjoying a little breeze by opening one of the car's doors. Cars of this type were generally used to transport express consignments called L-C-L ("less-than-carload-lot") shipments.

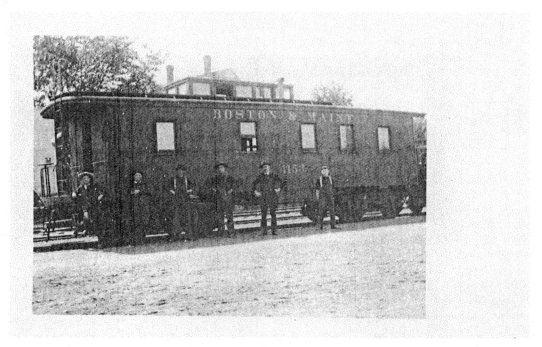

Boston and Maine caboose #4153 provides an appropriate backdrop as the crew crowds around to have their picture taken. Many stories have been told about cabooses being their crews' home away from home when laying over at some distant terminal. While workers like these often did enjoy having a glowing pot-bellied stove with coffee and a pot of hearty stew simmering on its top, these cabooses were more typically rolling office cars from which the job foreman directed the work, be it wreck clearing, bridge building, or just spreading plain old gravel.

Caboose of this class were built between between 1898 and 1910 at the Boston and Maine's Lyndonville and Concord shops. (Douglas Stamford collecion)

MAINE CENTRAL in New Hampshire

Mountain Division

1604 ELEPHANT'S HEAD AND ENTRANCE TO CRAWFORD NOTCH, WHITE MOUNTAINS, N. H.

The Crawford Notch gateway was discovered by a pair of hunters named Nash and Sawyer who followed a moose along a mountain stream which entered into a beaver meadow on the far side of the mountains. It was through this spectacular passage that the Maine Central Railroad's predecessor, the Portland and Ogdensburg, penetrated the White Mountains.

Shortly after the Civil War the Portland and Ogdensburg Railroad was chartered to build a line from the coast of Maine to Ogdensburg, New York, on the St. Lawrence River. By 1875 some 80 miles of track had been opened for service into the White Mountains and through the Crawford Notch gateway.

The worn rock outcropping at the left is known as Elephant's Head; with a little imagination it can indeed suggest a resemblance to a pachyderm's cranium.

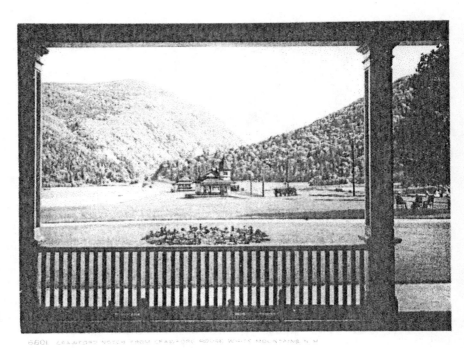

6801 CRAWFORD NOTCH FROM CRAWFORD HOUSE, WHITE MOUNTAINS, N. H.

This view, taken from the front porch of the famous Crawford House hotel, shows the beautiful little Crawford Notch depot and its natural surroundings. Although the Crawford House is gone, victim of a fire in 1977, the depot is still very much in use at this writing, housing the ambassadors of the local tourist trade. Just beyond the Maine Central's Crawford Notch station the Portland and Ogdensburg station can be seen in this 1903-copyright view. Although the Mountain Division has been out of operation for a number of years, periodically proposals emerge to re-open the line through the notch as a scenic railway to help attract tourists to the region.

Ever since the Crawford Notch gateway was discovered by those errant moose hunters in the early 1700's, the notch has been populated by some truly colorful characters. In the early years of this century one of the best known of these was "English Jack," a former sailor who lived in a small shack above the gateway. Before his death in 1912, at the age of 90, he became something of a tourist attraction himself, telling tall tales of his days in the King's Navy and selling trinkets and postcards to visitors. His house was just beyond this rock cut, to the left of the railroad.

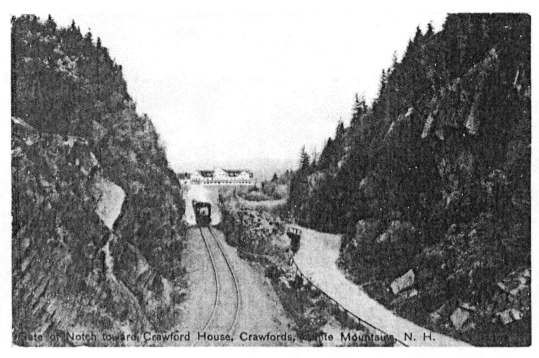

Gate of Notch toward Crawford House, Crawfords, White Mountains, N. H.

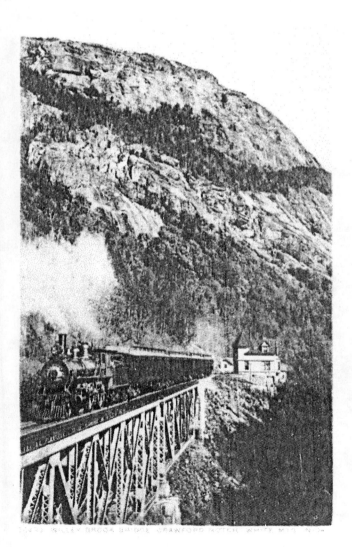

The spectacular Willey Brook Bridge was opened for service by the pioneer Portland and Ogdensburg railroad in 1875. After 30 years of service the Maine Central replaced the original iron span with this steel bridge in 1905. The bridge was replaced in an operation which took but nine minutes to complete, rolling out the old bridge, and rolling in the new one.

Willey Brook Bridge had the distinction of having a hotel at each end. On one end was the popular Crawford House and at the other was the Willey Brook House. A section house for track and bridge service and maintenance was located near the bridge, and a birdhouse in the form of a miniature of the section house was mounted on a tall pole alongside the bridge.

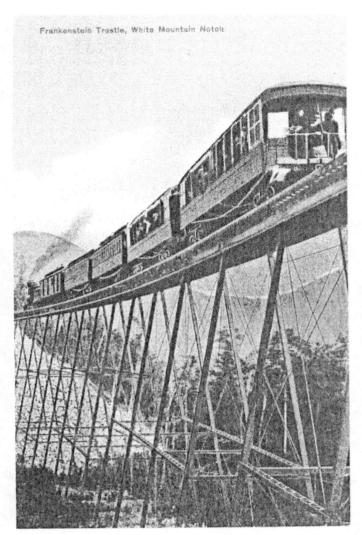

Approaching the gateway from the south, the line skirts along a ledge on the rocky flank of Mt. Willard before crossing over the Saco River on the spectacular 500-foot-long Frankenstein Trestle. The Portland and Ogdensburg was leased to the Maine Central system in 1888 and in 1895, after twenty years of service, the original iron trestle was replaced with the steel one seen here.

While the name undoubtedly conjures up thoughts of the monster of literary and silver screen fame the trestle was really named after Godfrey N. Frankenstein. Frankenstein was an artist who depicted the grandeur of the valley and the cliffs above it on canvas, and whose name in time came to be attached to the valley he so lovingly recreated.

Excursions through the gateway were quite popular, and here we see a balloon-stacked woodburner leading the way, with a pair of open-sided excursion cars bringing up the rear in a view which dates back into the late 1890's.

In a sight seldom seen on this side of the Colorado Rocky Mountains and that state's one remaining narrow-gauge railroad, Mount Willard's precipitous Frankenstein's Cliff towers above a train traversing a roadbed hewn from solid rock. In a panorama which surpasses grandeur, the incredible beauty of the Presidential Range is laid out for all to see. Here Mount Webster is seen across the valley, and rising in the distance beyond are Mounts Washington and Adams, New England's two highest peaks.

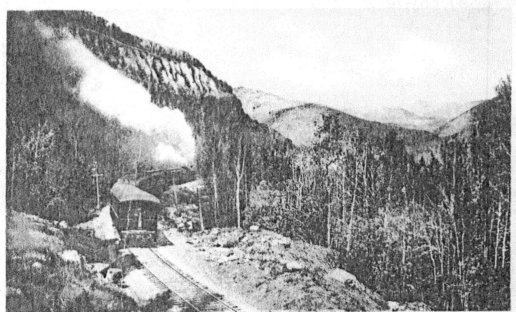

MT. WASHINGTON AND MT. ADAMS FROM FRANKENSTEIN WHITE MOUNTAINS N. H.

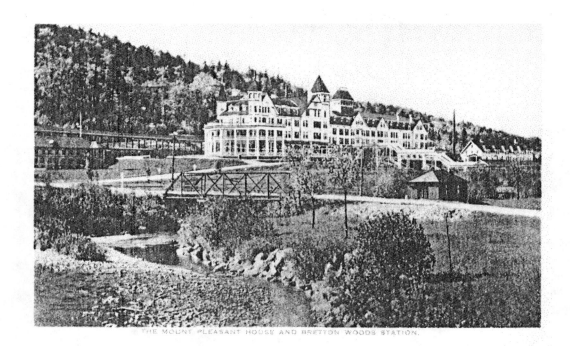

THE MOUNT PLEASANT HOUSE AND BRETTON WOODS STATION.

With the opening of the Portland and Ogdensburg railroad's line through Fabyan in 1875, the White Mountains were truly surrounded by a ring of steel studded with resort hotels. The opening of the line had the effect of elevating what had started as a simple country boarding house, the Mount Pleasant House, to the status of a major resort hotel. Exactly how major can be judged by the scope of the beautiful Mount Pleasant House as seen in this view.

The Maine Central ran behind the hotel while the Boston and Maine's tracks went by the front.

M. C. Station and Surroundings, Whitefield, N. H.

Whitefield, New Hampshire, once had the unique distinction of being able to boast not one, but three depots at the same time. The Boston and Maine's White Mountain Division ran through town and of course had to have a depot, while the late coming Portland and Ogdensburg, later the Maine Central, had to have one, too. The third depot, about a mile below town, was built at the junction of the Groveton branch. This made for cumbersome train movements, and eventually the Maine Central's trains pulled into the B&M depot, and then backed out to continue on their way.

Later the depot shown in this view was put out of service. It was eventually moved to a nearby hill top where today it serves as the home of a veteran's organization, but it's still very recognizable as a train depot.

MOUNT WASHINGTON COG RAILWAY

When Sylvester Marsh proposed building a railway to the top of New Hampshire's Mount Washington, one skeptical member of the State Legislature suggested that the charter they were being asked to approve might as well include an amendment granting permission "to extend the railway to the moon!" The Civil War delayed Marsh's plans, but he persevered and the first paying passengers rode to the top in 1869.

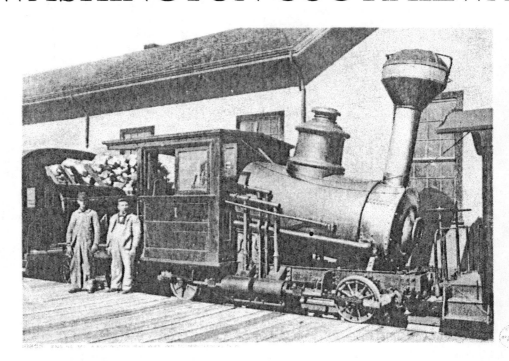

Sylvester Marsh left his Littleton home in 1823, at age 19, with just three dollars in his pocket. He went to Chicago were he made a fortune as a pioneer in the meat packing industry, only to lose everything and end up deep in debt following the great financial panic of 1842. While that could have been the end of Marsh's story, it wasn't. He paid off all his debts, re-established his fortune, and retired to his native state far richer than he had ever been. Building and operating the Cog Railway was to occupy him for the rest of his days.

The road was, and still is, a remarkable engineering achievement, with the steepest grade being 37.4% — about a four-foot rise in a ten-foot horizontal distance. A cog, or gear, under the steam locomotives engages a "rack" in the middle of the track, much as one's feet engage the rungs of a ladder. The boilers of the locomotives are tipped well forward to maintain a correct water level on the steep grades.

Built in 1883, locomotive #1, *Mt. Washington*, waits for passengers in this 1906 view. Boston and Maine trains reached the base station on that road's Fabyan Branch, and passengers could transfer directly to "The Cog" (as it's known to the locals) across this boarding platform. It was located below the present-day base station, alongside the railroad's shop building.

Almost the entire Mount Washington Cog Railway is built on trestlework. The steepest grade (seen here) is called "Jacob's Ladder" where the wooden structure supports the track as much as twenty feet above the mountainside. Heavy cables anchor the trestle here and elsewhere as protection against the high winds prevalent in the region. The highest wind ever recorded, 231 miles per hour, was noted by the U.S. Weather Service on the peak of Mount Washington in 1934.

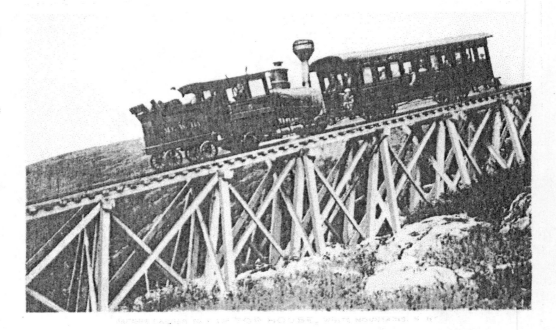

As might be expected, careful inspection and maintenance is required to keep such a unique railroad operating safely. In the early days track inspectors would sometimes ride down the mountain on sliding boards, nicknamed "Devil's shingles." While a normal ride down the mountain would take about fifteen minutes, some daredevils made the trip in only three. Speeds well in excess of 60 miles per hour were sometimes attained on the sliding shingles. The practice was outlawed after a rash of accidents.

Old Peppersass, the very first Cog Railway engine, was built in 1866. Upon delivery the locomotive was christened *Hero* but an old timer who saw the contraption thought it looked more like a bottle of Peppersass, a hot sauce mountaineers would douse liberally onto their baked beans. Inevitably, the name stuck. After twelve years of service, *Peppersass* was laid aside as worn out. She was not scrapped, but instead was displayed at the World's Columbian Exposition in Chicago, later at the Field Museum of Natural History in Chicago, and in 1904 at the Louisiana Purchase Exposition in St. Louis.

When *Peppersass* returned to the Cog Railway in 1929 an elaborate welcoming program was prepared. After speeches and a rechristening ceremony, *Peppersass* made its last trip up the mountain on July 20, 1929, but on the way back down the front axle broke and the engine ran away. All but one on the locomotive jumped for their lives; the man who remained, a photographer, was killed when the engine flew off the reverse curve just below Jacob's Ladder and smashed on the rocks below. The boiler flew off the wreck, right past a terrified photographer who stood transfixed, camera in hand, thereby missing the shot of a lifetime. The broken parts were taken to a Boston and Maine repair facility, where they were reassembled for display at the base station where it can be seen today.

This view shows the old engine only minutes before the wreck. At the right is a special car towed behind the train which preceded *Old Peppersass,* for the convenience of newsreel photographers.

OLD PEPPERSASS, WRECKED, JULY 20, 1929 —

GRAND TRUNK RAILWAY
in New England

Grand Trunk R. R. Station. Street view. Island Pond.

The Atlantic and St. Lawrence Railroad, predecessor of the Grand Trunk, was chartered in the 1840's with the audacious plan to build a rail line from Portland, on the coast of Maine, through the mountains of northern New Hampshire and Vermont to Montreal, Quebec.

The project was the brainchild of John A. Poor of Portland. In 1845, when Poor heard that a Boston group was in Montreal attempting to sway the burghers of that city to thinking that Boston was the logical outlet for their goods, he set out in a sleigh in the midst of an early February nor'easter. Just five days later, after traveling the route of his proposed railroad, Poor strode into a meeting of Montreal's Board of Trade, swept the Bostonians before him and saved the day for the Atlantic and St. Lawrence and for Portland.

The line was constructed under both American and Canadian charters and was opened in July, 1853. The track separation used was a unique 5 feet 6 inches, ostensibly chosen to prevent the use of the trackage in any invasion of Canada in time of war!

Shortly after completion the A & St.L was taken over by the Grand Trunk Railway. Only after much wrangling and the consolidation of several other lines into the competing Maine Central system, which used the standard 4 foot $8^1/2$ inch gauge, did the Grand Trunk cast off its albatross and convert the line to "standard" gauge.

The substantial brick and stone depot at Island Pond was located in the northeastern corner of Vermont, 149 miles from Portland and the Maine coast. It was the last stop on the Grand Trunk south of the Canadian border, and was right in the heart of town. A small yard was located right across the tracks from the depot.

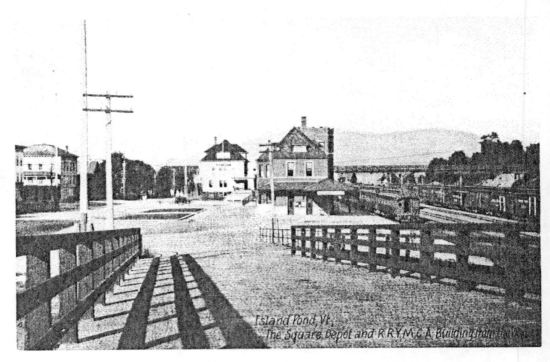

Island Pond, Vt.
The Square, Depot and R.R.Y.M.C.A. Building from the ...

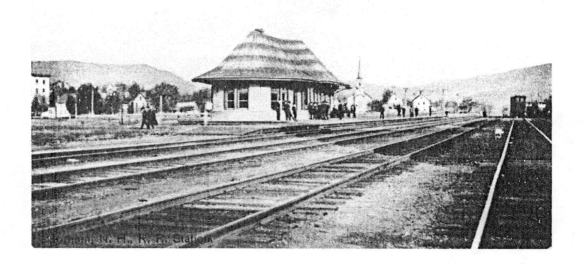

Gorham was and is a paper mill town, located north of New Hampshire's White Mountains, about 90 miles from Portland. The station, like the one at Yarmouth, Maine, has the characteristic Grand Trunk architectural features, with rounded ends and the town name painted on the roof.

Grand Trunk Station, Yarmouth Maine

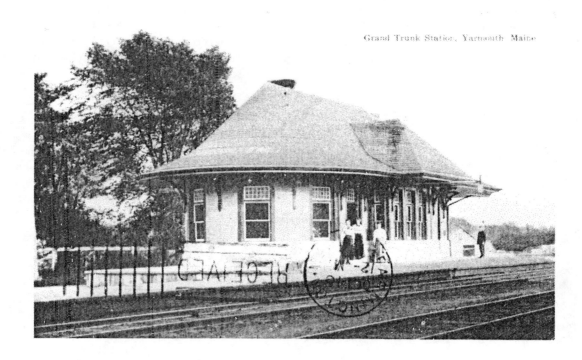

Yarmouth is located right on the tourist coast of Maine. A small freight interchange yard was located in the community, because there was a crossing with the Maine Central which had its own station to accomodate passengers. Yarmouth depot was renovated in 1975 and today is preserved by the Yarmouth Historical Society. Note the town name on the roof.

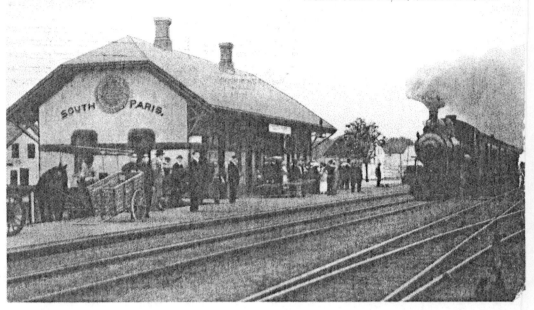

South Paris, Maine, about 47 miles inland from Portland, was the junction for a short extension to Norway, Maine. This brick station was built in 1889. It is unusual to find a brick country depot in a state where most small town stations were built from the more readily available forest products.

Nearby, the Grand Trunk crossed the Little Androscoggin River enroute to Portland on this spindly deck bridge supported by some truly massive stone abutments. (lower view)

It was the Grand Trunk, with only a slender finger of track crossing the region, that set off the last of New England's railroad turf wars. Shortly after the turn of the century the Boston and Maine and Maine Central railroads fell under the control of the New Haven, thereby creating an almost total monopoly of transportation in New England. At the same time the Canadian Pacific had just completed the first true transcontinental railway, running from coast to coast.

In an attempt to become more competitive under those circumstances, the Grand Trunk sought to gain better access to the Atlantic seaboard by proposing to build new rail lines, diagonally across New England, to reach the port cities of Boston and Providence, under the auspices of a subsidiary to be called the Southern New England Railway.

As the Grand Trunk was backed by British interests, the railroad's president, Charles Hays, sailed to England in 1912 to consult with his financiers. Unfortunately, he booked his return passage aboard the *R. M. S. Titanic*. Although some construction was begun, without Hays' dynamic leadership the Southern New England Railway foundered, making it perhaps the first railroad to be lost at sea.

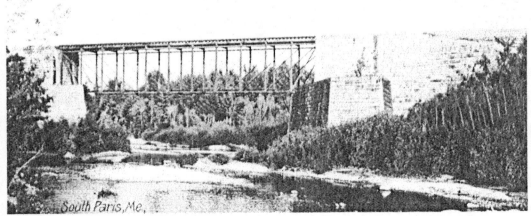

South Paris, Me.

G.T. Bridge over Little Androscoggin River

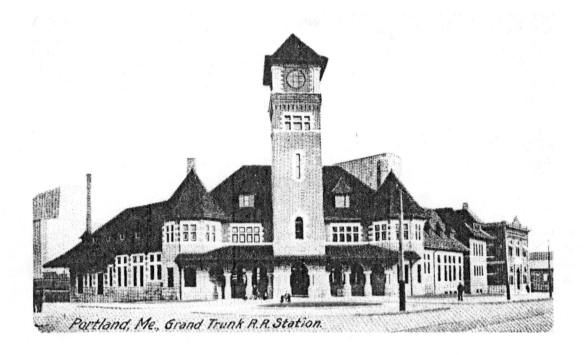

Portland, Me., Grand Trunk R.R. Station.

This station at Portland, Maine, was the third depot to serve the Grand Trunk in that city. Built in 1903, it replaced an old-fashioned covered station. The structure was a masterpiece of stone and brick construction with a red tile roof and marble accents.

While passengers arrived and departed at this station, freight crews switched cars in the nearby freight yards and at the tall grain elevators. At the turn of the century export agriculture was as important a source of revenue as the famous Maine potatoes are today. The elevators were built adjacent to the Grand Trunk's wharves to facilitate easy loading of outbound grain ships as even in those days the Americas were feeding foreign lands.

The station was razed in two sections. The clock tower went in 1948 and the rest of the handsome structure followed in 1966.

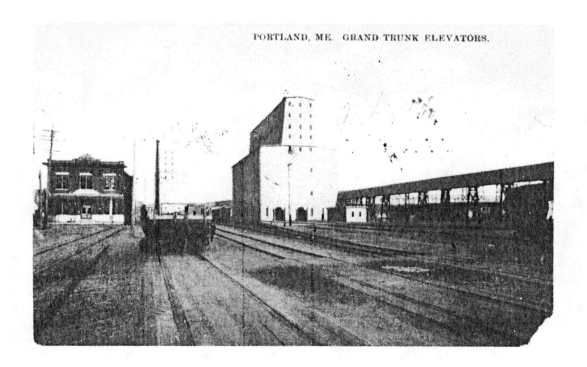

PORTLAND, ME. GRAND TRUNK ELEVATORS.

BOSTON AND MAINE RAILROAD in Maine

The Union Station at Portland, Maine, served both the Boston and Maine and the Maine Central. Built in 1888, the commodious structure was a late Victorian masterpiece of granite turrets and dormers topped with a clock tower. Trains waited under the covering canopy on the track side of the station, where four tracks were protected from the weather and passengers could detrain directly into the waiting rooms.

This commanding structure was surrounded by the Portland community until the station's demise in 1961.

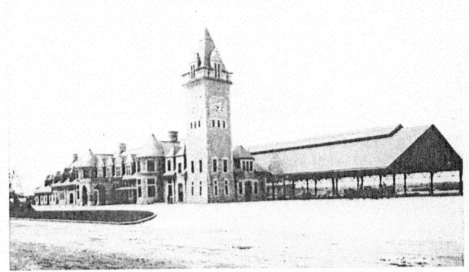

664—UNION STATION, PORTLAND, ME.

One might wonder why two major depots were built in Portland in the space of 15 years, when it would have been so much easier and convenient for the Grand Trunk to share the Union Station with the Maine Central and the Boston and Maine. The answer to this perplexing question can be found in the corporate boardrooms of the latter two roads.

At the turn of the century the B&M and the Maine Central were controlled by the same interests, and even shared the same directors. Those interests resented the Grand Trunk's intrusion into their domain, hence relations between the Maine roads and the Grand Trunk had a decided chill about them.

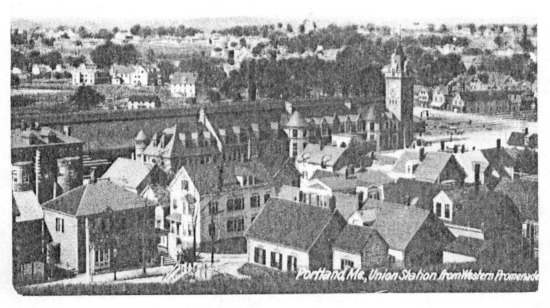

Portland Me, Union Station from Western Promenade

(next page) Old Orchard Beach station was a terminal of the very short "Dummy Line" whose tracks ran along the Atlantic shoreline between the beach and the waterfront cottages, on its way to Camp Ellis on Saco Bay, a distance of just three miles. The passenger coaches for this branch line originally ran on a narrow gauge railroad and looked awkward perched on standard gauge trucks.

The nickname "Dummy Line" came from the small four-wheeled steam locomotives which served the line when it opened in 1880. Although generally conventional in appearance, their small size gave the cab and smokestack a curious outsize look. Both locomotives came second hand from metropolitan street railways and had been especially designed to run making less noise than a standard steamer. As they were "habitually silent" they were nicknamed "dummies." While they were later replaced by more common 4-4-0 American type locomotives, the name stuck.

The original passenger coaches were also purchased second hand. They came from an abandoned narrow-gauge railroad and looked awkward perched high up on standard gauge trucks. The coaches were open-sided, with roll-down canvas curtains and footboards running the length of the car.

There were no turning facilities on the line, so on the return trip to Old Orchard, the engine backed up, pushing its train. The line operated from mid-June to mid-September. In 1901, the fare was a dime, and the trip took 20 minutes. Fifty thousand passengers were carried in the first twelve seasons.

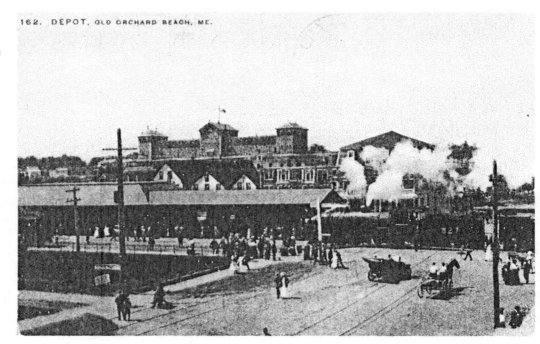

162. DEPOT, OLD ORCHARD BEACH, ME.

Old Orchard Beach was a resort community in its own right, with seven miles of gleaming white sand beach, oceanfront hotels, and hospitable warm waters (in the summer). In 1898 an 1800 foot long steel pier was built out into the ocean, at the end of which a magnificent casino was built. A miniature railroad ran the length of the pier and an orchestra played every night during the tourist season, in a manner designed to make every patron feel like a millionaire.

Unfortunately, the casino was promptly washed away in a Thanksgiving-night gale, although the pier was undamaged. The Casino was rebuilt, but in August 1907 the resort community was swept by a fire, the casino being saved only by tearing up the wooden decking of the pier to keep the flames away. The town was rebuilt but the bad luck continued, until in 1909 a March storm washed away the middle portion of the pier. The Casino was rebuilt near what had once been the midpoint of the pier and the last 1000 feet of the pier was dismantled.

This view shows a typical passenger train at the Camp Ellis station and pier. Located on Saco Bay, Camp Ellis was the end of the line for the "Dummy." Although the Orchard Beach Railroad was built under a separate charter, it was absorbed by the neighboring Boston and Maine in 1892. Service on the Dummy Line ceased in 1923. After abandonment the station at Camp Ellis was used as a store, and later was presented to a religious order. It was finally dismantled in 1960.

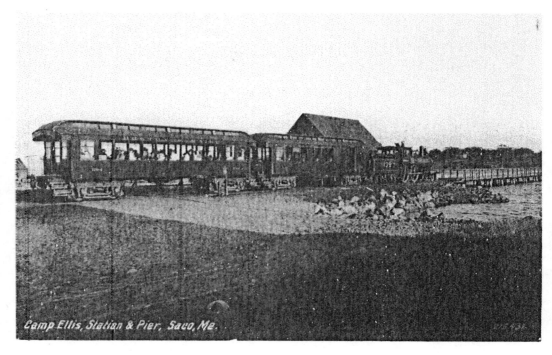

Camp Ellis, Station & Pier, Saco, Me.

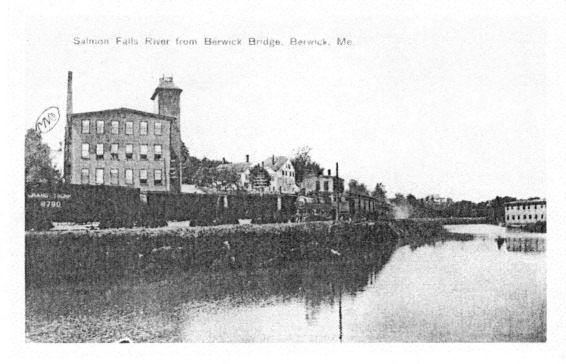

About 45 miles south of Portland, the Boston and Maine crossed the Salmon Falls River enroute to Berwick, Maine. Throughout New England, as elsewhere, railroads often hugged river banks to secure the easiest grades and the best rights-of-way for laying track.

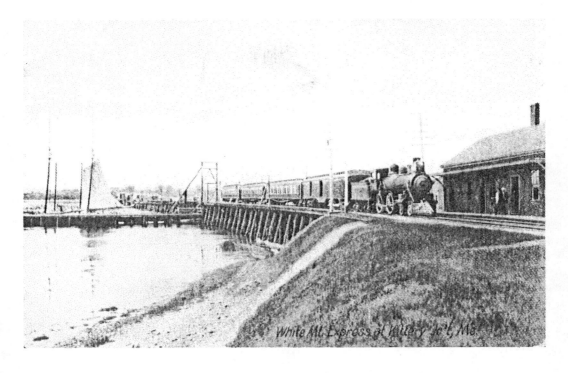

White Mt. Express at Kittery Jc't, Me.

Kittery and Kittery Junction, Maine, across the Piscataqua River from Portsmouth, New Hampshire, was where the track divided with a branch running along the shore to York Beach while the main line went on to North Berwick and Jewett. The Piscataqua is a wide and deep river, and in the early twentieth century a drawbridge in the middle of the railroad trestle allowed shipping to pass; it is seen in this view just beyond the *White Mountains Express*. The drawspan of this bridge was an unusual type often called a "jackknife," from the way it hinges open, pivoting to the side.

Like many river crossings this was a dangerous bridge for early railroaders. In one instance a 4-6-2 Pacific-type locomotive derailed on the bridge and went in the water where, not surprisingly, it sank like a lead balloon. It was never salvaged and still inhabits a watery grave.

66

Alfred, Maine was located almost 33 miles from Portland on the Boston and Maine's interior route to Rochester, New Hampshire. In the 1840's it was the site of a Shaker village. At its height the Boston and Maine operated three parallel lines from Portland through the rolling hills along and across the small streams into New Hampshire. The first of these lines ran along the coast from Dover, New

Alfred, Maine., View of Railroad

Hampshire, to Portland. The second began at Portsmouth and looped along the coastal towns and resort communities, occasionally intersecting the line from Dover along the way to Portland, while the inland route ran between Rochester and Portland by way of Sanford, Springvale, and Alfred.

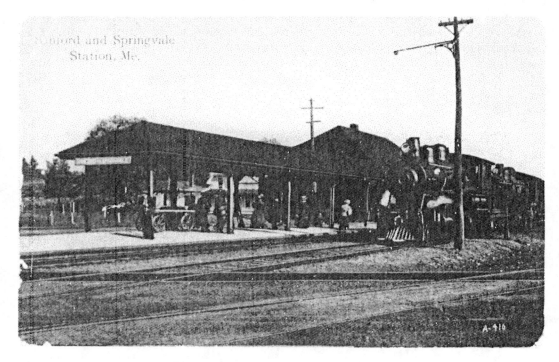

Sanford and Springvale Station was on the interior line of the Boston and Maine about 36 miles from Portland. This postcard shows the later station with its long covered platform playing host to a doubleheaded passenger train led by a pair of highwheeled American type 4-4-0 locomotives. That wheel arrangement was so universally used in the early days of railroading in the United States that it became known simply as the American Standard locomotive. A close look at the engines finds an engineer employing his long-spouted oil can on the valve gear of the road engine, a necessary precaution in the days before automatic lubrication.

The pole in the foreground carries a trolley wire for the York Utilities Company, which operated passenger and freight service between Sanford off to the right and Springvale to the left. This was the last trolley line in Maine, operating into the 1940's.

MAINE CENTRAL RAILROAD in Maine

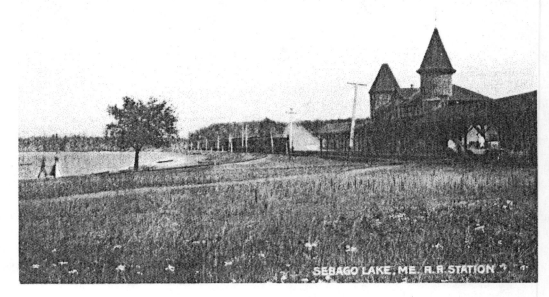

The Maine Central Railroad's trackage fanned out from Portland like the spokes of a wheel, with each branch going out into the Maine interior or along the coast, ever northward. The Maine Central was the product of the consolidation of the Penobscot and Kennebec and the Androscoggin and Kennebec in 1862, and gradually almost all the shortlines in central and southern Maine were gathered into the Maine Central fold as that road became the dominant rail company in Maine.

Sebago Lake station is 16.7 miles north of Portland on the route opened through Crawford Notch into the White Mountains of New Hampshire by the Portland and Ogdensburg in the 1870's. With its ornate towers, one square and one round, this classic structure served as an elaborate debarkation point for summer tourists visiting the Sebago Lakes Region.

Here on the platform, about 1905, is a horde of summer tourists waiting for the train. Summer train travel "down east" was a popular pastime in the days prior to the automobile. Vacationers discovered Maine's rural charms shortly after the Civil War, and all of Maine's railroads operated special trains to provide fast, efficient service from the metropolitan areas to the mountain and lake resorts.

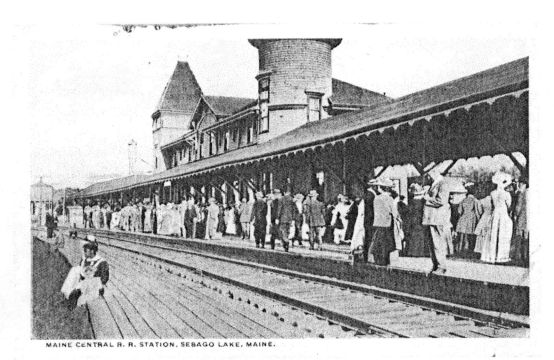

MAINE CENTRAL R. R. STATION, SEBAGO LAKE, MAINE.

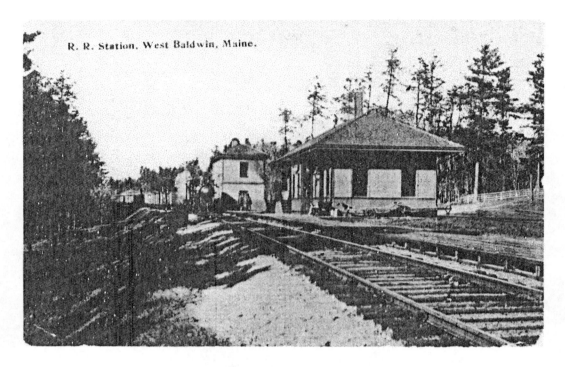

R. R. Station, West Baldwin, Maine.

West Baldwin station was also on the former Portland and Ogdensburg line, one stop east of Bridgton Junction. Here's a freight train taking on water from an unusual enclosed water tank. Steam locomotives used prodigous amounts of water and Maine winters could easily freeze solid the contents of the cistern, so water tanks were sometimes enclosed so they could be heated with a stove to minimize this difficulty.

The Turner Centre Creamery Company was one of the largest dairy operations in the state of Maine, with creameries located at many of the major railroad yards. This one was located at Auburn, 36 miles north of Portland, right across the tracks from the passenger station. The depot was removed in 1956.

From a main line between Auburn and Bangor, the Maine Central Railroad's branches ran north like the tines of a giant rake to reach towns like Rumford Falls, Farmington, Kineo, Skowhegan, Dover-Foxcroft, and Mattawamkeag, winnowing out the products of mountain lakes and forests and returning tourists, sportsmen, and finished goods.

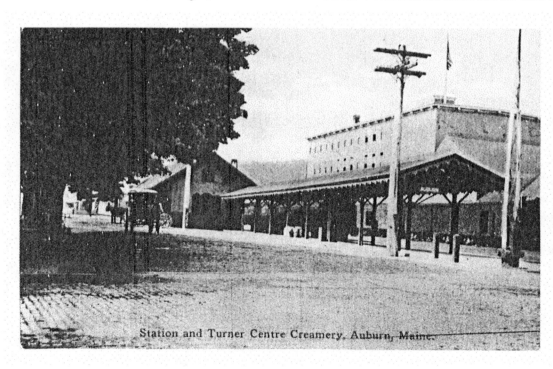

Station and Turner Centre Creamery, Auburn, Maine.

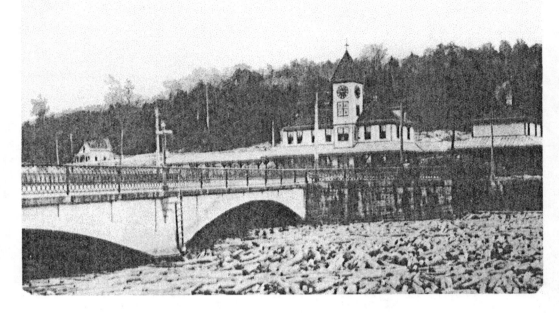

At Rumford Junction, just south of Auburn, the tracks divided with one line going to Auburn and Lewiston, while the other looped around and headed north toward the Rangeley Lakes region. Fifty-three miles up this branch were Rumford and Rumford Falls. This line was originally built by the Portland and Rumford Falls Railroad, which was later absorbed into the Maine Central. Note the two-story wooden depot's interesting tall square clock tower.

In this 1914 view the river is clogged with logs being floated to the nearby Oxford Paper Mills. At the turn of the century most logging was done in the wintertime. Logs would then be dragged to the nearest stream and, with the coming of spring, the logs were floated to the sawmills on the crest of the spring floods.

At their destination the logs were frequently stored in rivers and ponds because, in addition to protecting the logs from fire and insect damage, the water softened the bark and allowed mud and debris to wash off the logs reducing possible damage to the mill saws.

Major freight commodities from the Rumford Falls region were paper and wood pulp products, and one of the largest producers of paper was the Oxford Paper Mill complex.

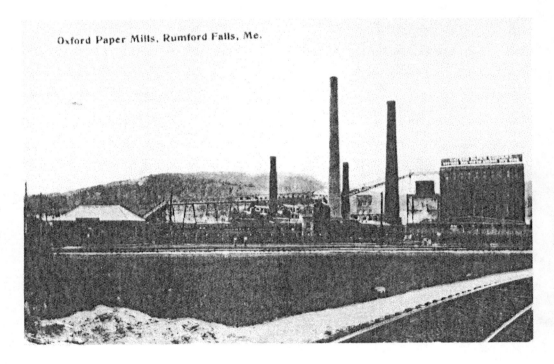

Oxford Paper Mills, Rumford Falls, Me.

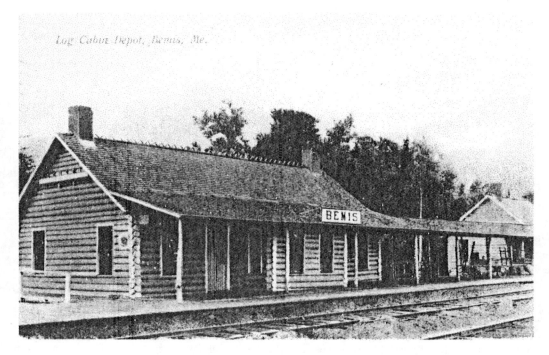

Log Cabin Depot, Bemis, Me.

Located on the Rangeley Lakes line about 79 miles north of Rumford Junction, Bemis was unique as the only log-cabin station in Maine, and possibly the only one east of the Mississippi. This early depot was eventually replaced by a more conventional station and finally it was put out of service as the effects of the great depression caused less and less need for passenger trains.

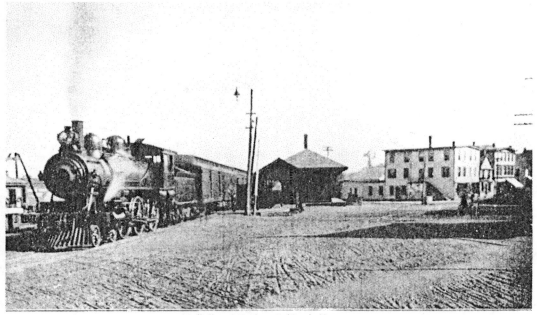

Pub. for Foster's Drug Store

Railroad Station, Oakland, Me.

Oakland, Maine, 79 miles from Portland, was the junction between the Maine Central and the Somerset Railroad which ran northward along the Kennebec River to Kineo on Moosehead Lake. Chartered in 1860, the Somerset was opened to Norridgewock in 1873 and completed through Madison in 1875. Later the Maine Central acquired and operated the Somerset line. In this turn-of-the-century view, a 4-6-0 ten-wheeler leads a passenger run up the line. By the 1930's the platform near the track was removed and the rutted dirt roadway seen here was tarmacked.

Enroute to Kineo the Somerset and later Maine Central Railroads crossed the Kennebec River at Norridgewock on this unusual covered deck bridge, built in 1873. The more common type of covered bridge had the tracks running through the bridge with the sidewalls protecting the timbers and underpinnings and keeping snow from the rails and ties, but from an engineering standpoint there's no reason why the top can't be designed to support the track. With minimal maintenance covered bridges would last many years, the timbers safe from the ravages of the weather.

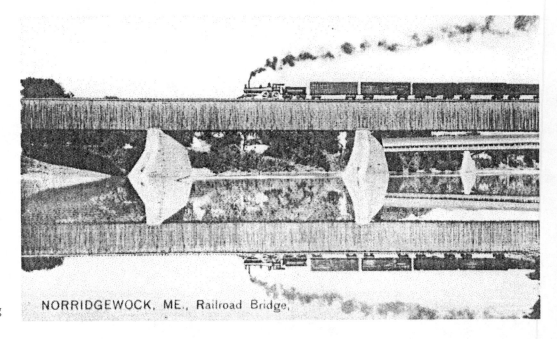

NORRIDGEWOCK, ME., Railroad Bridge.

In a covered bridge of this length, smoke dispersal could well be a problem with tracks located inside the structure.

Note the shape of the stone supporting piers. The steeply sloped ends pointing upstream helped break up ice floes, thus assisting in keeping the bridge from being washed away by spring freshets.

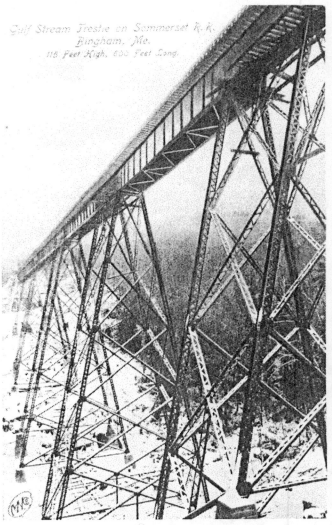

Gulf Stream Trestle on Somerset R.R. Bingham, Me. 115 Feet High, 600 Feet Long.

In a land where spectacular bridges are commonplace, occasionally even short branch railroads boasted some real winners. The 23-mile-long Somerset Railroad had a dandy in its 600-foot-long Gulf Stream Trestle near Bingham. The structure towered 115 feet above the ground at its highest point and offered a spectacular view of the countryside.

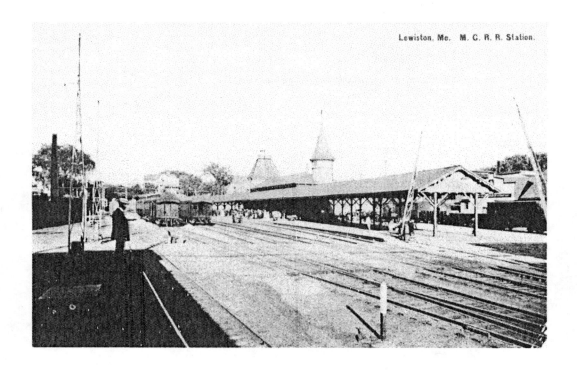

Lewiston, Maine, 37 miles from Portland on the line through Auburn, has had three stations. The first was a covered depot. The second, pictured above, was built of wood and had both square and round towers, as at Sebago Lake. This depot was replaced with the new brick station in the lower view which was postmarked in 1923. Lewiston was a central location for trains running from the coast to connect with those on interior lines. Even the Grand Trunk offered a connection in the Auburn — Lewiston area with service into the White Mountains on its line to Berlin, New Hampshire.

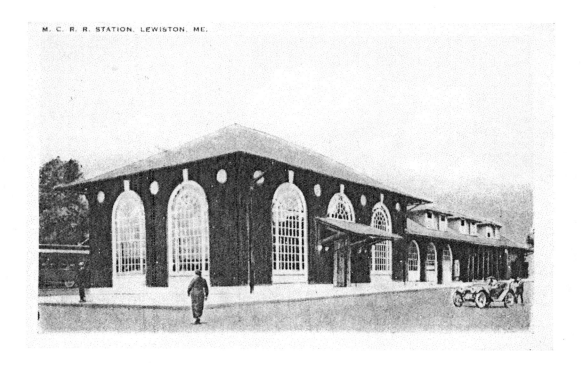

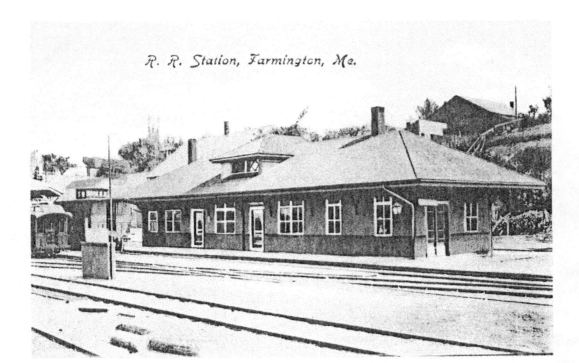

R. R. Station, Farmington, Me.

Farmington, Maine, 82 miles from Portland at the end of the Farmington Branch, was the junction and transfer point for passengers and freight bound for the lilliput Sandy River and Rangeley Lakes whose track gauge was just two feet. Note at the left of the view the two-foot-gauge passenger coach, tiny in comparison with the standard-gauge caboose on the adjacent track.

The railroad yard had tracks of both two-foot and standard gauge, and had four crossovers. Next to the station was a covered canopy over the two-foot-gauge tracks. This station replaced an earlier covered depot, and continued in service after the Sandy River line was abandoned in 1936. Eventually the Maine Central abandoned the line, and tracks were taken up as far back as Livermore Falls. The station became a laundry. (More on the Sandy River on page 97.)

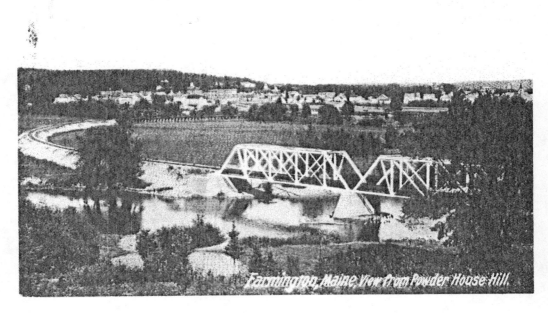

Farmington, Maine, View from Powder House Hill.

The Maine Central entered Farmington on a bridge over the Sandy River from West Farmington. In this view from Powder House Hill the long sweeping curve of the rail line can be seen as it entered town on an earth fill. This fill was originally built as a long trestle, and gradually over the years dirt was dumped over the tracks and piling to form the fill as it's seen here.

Powder House Hill takes its name from a gunpowder storehouse which was built atop the hill in colonial times.

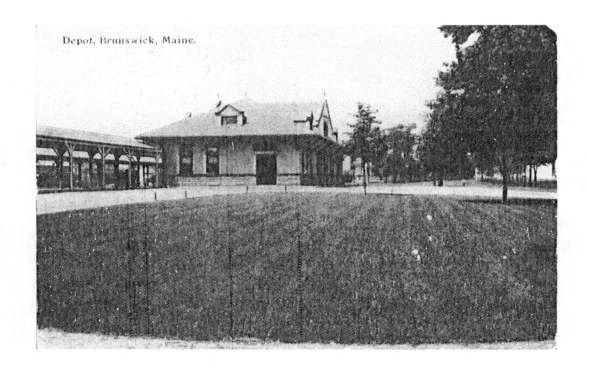

Depot, Brunswick, Maine.

Brunswick was the junction point for branches running to Lewiston, Waterville, and Rockland. First settled in 1627, Brunswick is located 29 miles north of Portland. An extensive freight yard was located there to handle freight cars from three directions.

At the turn of the century freight cars were built of wood and were trussed with metal rods under the car to help hold them together. The rods could be tightened by turning a turnbuckle under the car, or a nut on the end of the rod, to compensate for wear. This operation was undertaken at handling yards like this one by railroaders nicknamed "car knockers" because they would walk around cars they were inspecting and bang on certain steel parts with a hammer. The ring of the metal would warn the inspector of a cracked or loose part.

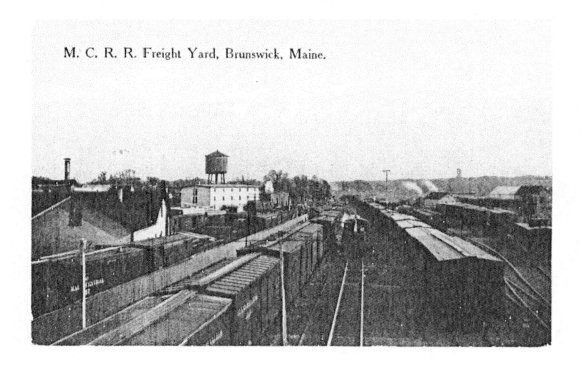

M. C. R. R. Freight Yard, Brunswick, Maine.

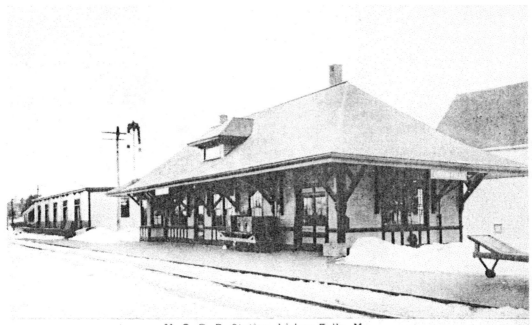

M. C. R. R. Station, Lisbon Falls, Me.

Lisbon Falls is on the Maine Central line to Lewiston, 8 miles north of Brunswick. Note the freight house beyond the station; it's typical of the Maine Central style with a low roof and large doors.

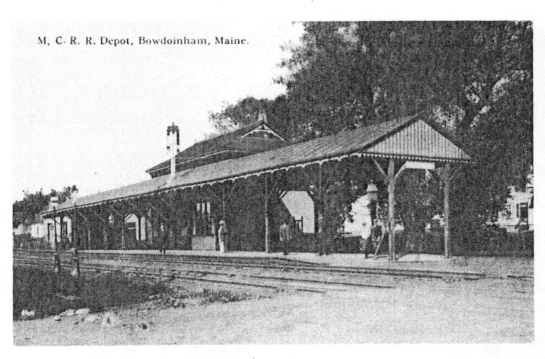

M. C. R. R. Depot, Bowdoinham, Maine.

Thirty-six miles from Portland on the Waterville line out of Brunswick is Bowdoinham. The tidy clapboard depot had a covered platform which extended along the track toward the small freight house beyond. Small freight houses were used to hold less-than-carload freight while awaiting shipment or customer pickup. Whenever possible, freight houses were located close to the stations for the convenience of station agents and baggage handlers.

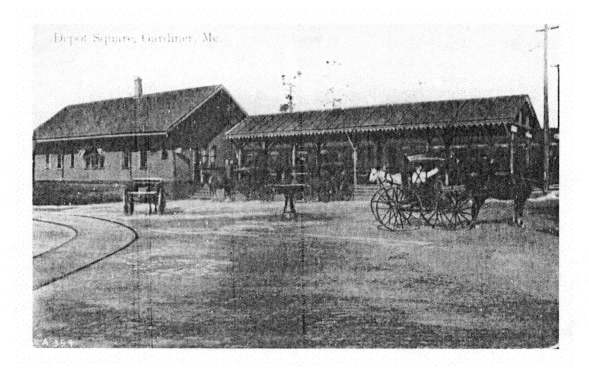

These views show the depot and depot square at Gardiner, Maine. The original depot, built in 1851, was replaced by the very attractive two-tone brick structure in 1911. The city trolley line made a loop at the station, and its track is seen in the upper view. The depot was next to the entrance of the covered bridge over the Kennebec River to Randolph. The Maine Central's tracks followed the river, and the yards at Gardiner were located south of the station.

Note the horse watering trough in the square, an essential item in the days before Henry Ford's flivvers put most of the horses out to pasture.

The area around Gardiner was well wooded at the turn of the century, and in addition to the more common forest products, tanbark, used in tanning leather, was an important product of local industry. Its availability was an important factor in the development of a number of shoe factories in the neighborhood. One of the largest of these was the Commonwealth Shoe and Leather Company, whose impressive five-story brick and glass structure was built right alongside the river in Gardiner.

Randolph, at the other end of the covered bridge over the Kennebec River, was the terminal of the two-foot-gauge Kennebec Central Railroad, which carried passengers and supplies to the Old Soldiers' Home at Togus. (More can be found on the Kennebec Central on pages 98-99.)

M. C. R. R. Depot, Gardiner, Maine

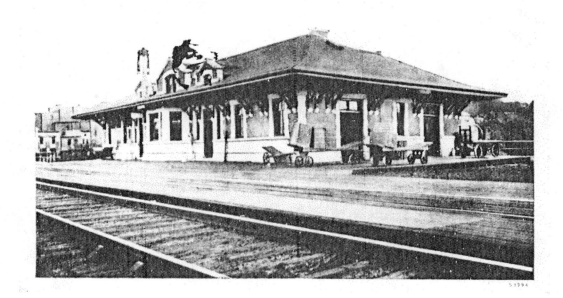

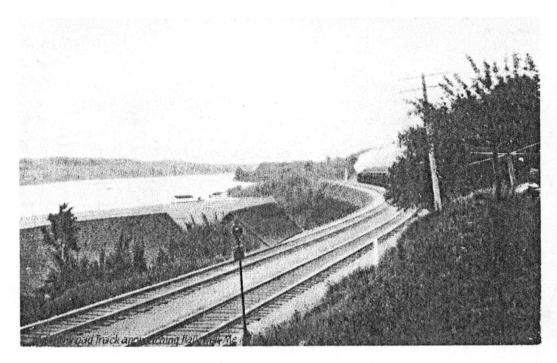

Hallowell, Maine, located between Gardiner and Augusta, is by the Kennebec River. Incorporated as a town in 1771, Hallowell was famous in the nineteenth century for the light-gray granite quarried there. The Maine Central's double-tracked main line paralleled the river enroute to Augusta. Note the beautiful condition and alignment of the roadbed and tracks in this early scene.

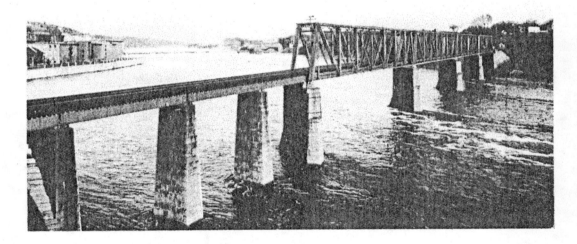

The Maine Central, leaving Augusta, crossed the Kennebec River on this long bridge which featured deck girders for its shorter spans, and trusses for the longer distances between piers.

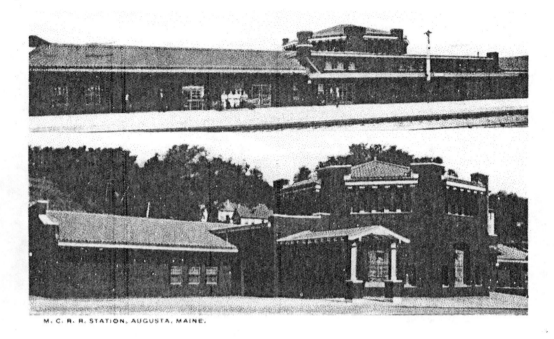

M. C. R. R. STATION, AUGUSTA, MAINE.

This fine brick station at Augusta replaced an older and smaller structure. It had two main-line tracks on the railroad side, and included large freight buildings on either end of the main passenger area. Augusta became the state capital, even though it was incorporated in 1797, later than many other towns across the state.

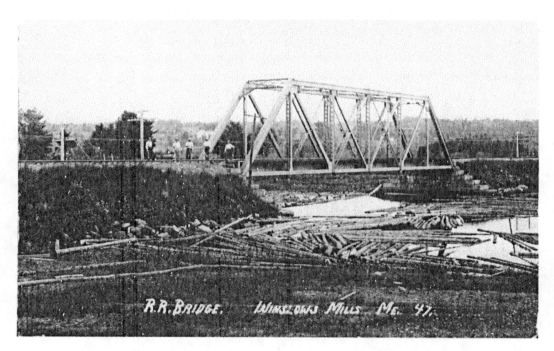

R.R. BRIDGE. WINSLOWS MILLS. ME. 47.

Winslows Mills, two miles east of Waldoboro, was on the Rockland branch of the Maine Central which crossed the Medomak River on this short truss bridge. Note the logs clogging the river, evidence of a great deal of logging going on upstream to supply sawmills down the river.

In this photographic postcard a crew of "Gandy Dancers," as track repair gangs were and still are known, is taking a moment to pose for the camera. In the days before mechanized tracklaying and repair, railroads were divided into sections and a track gang permanently assigned to each. To ease their heavy labor, members of track gangs would often sing while laying ties, spiking rails, and tamping ballast. Often their movements would fall into time with their chanteys, giving watchers the impression the men were dancing. Since one of the major manufacturers of track repair tools was the Gandy Manufacturing Company of Chicago, the section gangs eventually became known as "Gandy Dancers."

Waterville, 82 miles from Portland, was the Maine Central's junction for lines originating at Auburn/Lewiston, Skowhegan, Brunswick, and Bangor. At this station passenger trains from all over the state met to exchange passengers. At the right the track curves away from the station, and the platform follows right along. The red-and-white striped awnings around the second-story windows add a festive spirit to the

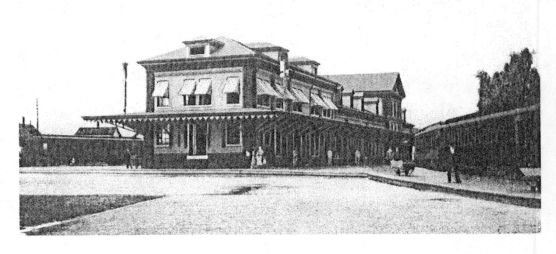

building in pre-air-conditioning days. Trains entering from Winslow on the other side of the Kennebec River crossed on the four-span truss bridge just above the falls, as seen in the lower view.

Waterville was the home of one of Maine's most unique products. From 1901 into the 1930's Alvin Lombard manufactured steam-powered logging tractors which looked something like a small railway locomotive mounted on chain-driven caterpillar tracks in the rear and skis up front. While the engineer toiled in a cab at the rear, the hardy steersman sat up front handling the steering wheel, completely exposed to the elements. Lombard's log haulers were relatively successful until outmoded by the gasoline engine; the lag link track he invented lives on under modern bulldozers and other heavy equipment.

Of the 82 or so log haulers built by Lombard, two surviving examples can be seen in New England. One is on display at the logging museum in Patten, Maine, and the other — which is operational — is at Clark's Trading Post at North Woodstock, New Hampshire.

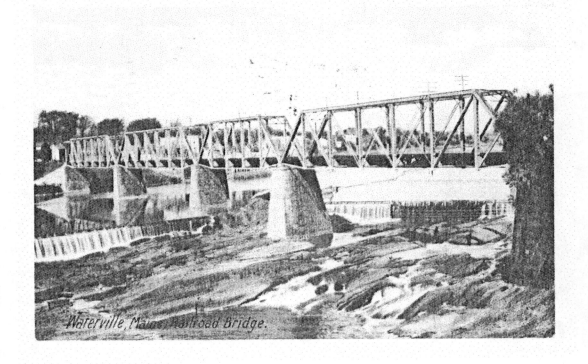

Waterville, Maine Railroad Bridge.

Skowhegan, Maine, was at the end of an 18-mile-long branch from Waterville. The station had the ubiquitous clock tower and the usual freight house, to the left of the station across the tracks. To get to Skowhegan trains crossed the Kennebec River on this two-span deck bridge.

There was a great deal of logging activity in the area

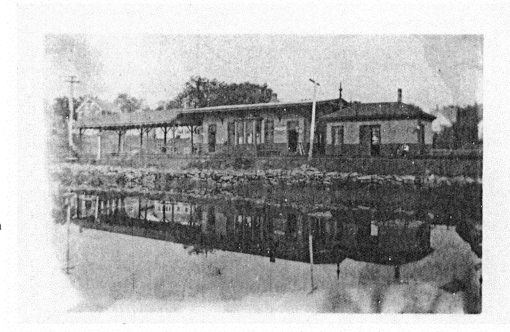

back in 1909 when this card was mailed, as evidenced by the large number of logs floating down the river. Skowhegan was also home to a large brick four-story shoe factory attracted, no doubt, by the readily available wood bark used in the leather tanning process.

Early settlers named the area Milburn; it is interesting to note that residents took back the original Indian name for the area.

Wiscasset, Maine was located on the Rockland branch, 47 miles from Portland. Wiscasset had a station and a large freight house located right on the banks of the Sheepscot River. The two-foot-gauge Wiscasset, Waterville and Farmington Railroad crossed the Maine Central line about 200 feet north of this station. Passengers could walk between this station and the WW&F station by crossing on a trestled walkway. First the large freight house and later the station itself were removed in the 1980's.

Besides being the self-proclaimed "Prettiest Village in the State of Maine,"
Wiscasset is home to two of the last four-masted schooners, the *Luther Little* and the *Hesper*, which have been grounded in the mud flats south of Route 1 since 1933. Acquired as part of a scheme of the last owner of the WW&F to ship lumber by sea to Portland and Boston, the pair have outlasted the narrow gauge, the wharves and docks to which they were moored, and even the Maine Central's operation of the Rockland branch.

Following the Maine Central's abandonment of the Rockland branch the line was acquired by the State of Maine, which at this writing leases it to a designated operator, the Maine Coast Railway, which earns revenue hauling freight and tourists on the scenic seaside line.

(More on the Wiscasset, Waterville and Farmington can be found on pages 100-101.)

Bath was the first major station on the Rockland branch, 36 miles from Portland and 9 from Brunswick. This handsome old station was built in 1871 with the usual Victorian trim and finials, and was replaced by a brick structure in the 1940's.

Ship building became a major industry in Bath. At the turn of the century the shore was lined with a succession of small shipyards cobbling together three- and four-masted wooden schooners for the

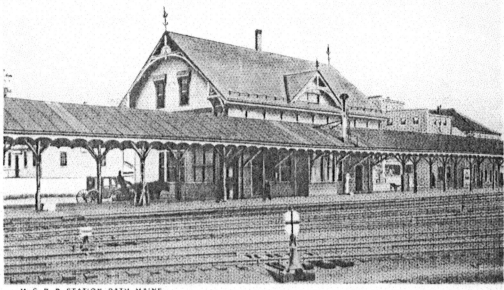

M. C. R. R. STATION, BATH, MAINE.

coastal maritime trade. Unlike other coastal Maine towns Bath has not forgotten this heritage, preserving the former Percy and Small shipyard on Washington Street as a reminder of the time when "Bath-built" became synonymous with "ship-shape."

In 1930, writing for a documentary movie, Maine lumberman Alfred Ames recorded what could well have been the epitaph of the wood boat yards when he lamented "In 1917 the schooner Lucy Evelyn was built at Harrington, Maine. Before the schooner was completed, we could have sold the sails and rigging at a profit of $10,000. Now we can not give the schooner away."

Somewhat belatedly Maine joined the age of modern shipbuilding when a steel-hulled coal schooner slid down the ways of the Bath Iron Works and out into the Long Reach in the year 1900. Since then the Bath Iron Works has built grand yachts, merchant steamers, and warships, continuing the tradition of "Down East" maritime craftsmanship.

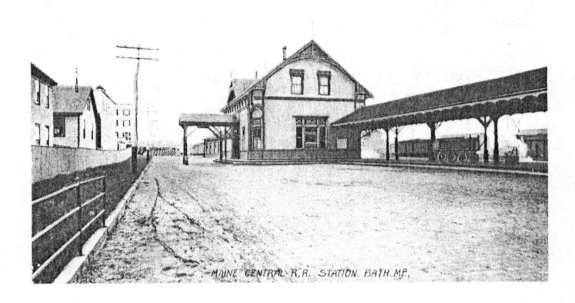

MAINE CENTRAL R.R. STATION, BATH, ME.

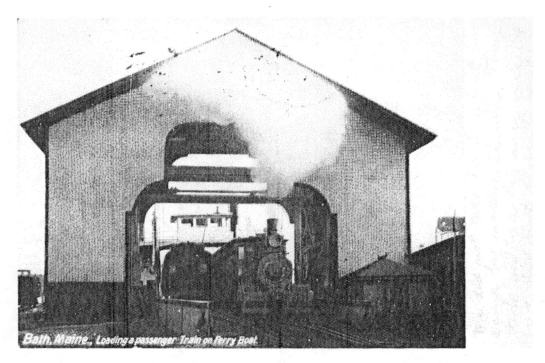

The Knox and Lincoln Railroad did not build a bridge to cross the wide Kennebec River from Bath to Woolwich, choosing instead to employ a ferry to carry the railroad cars across the river. Here a passenger train is being loaded onto the ferry across a counterbalanced "apron," a specialized form of loading dock. Loading a train onto the ferry was a time-consuming process, since the cars had to be added a few at a time, first on one side and then on the other to prevent the ferry from capsizing. The apron was built in such a way as to compensate for seasonal fluctuations in the height of the river. The Maine Central absorbed the Knox and Lincoln in 1891, but did not bridge the Kennebec river at Bath until 36 years later in 1927.

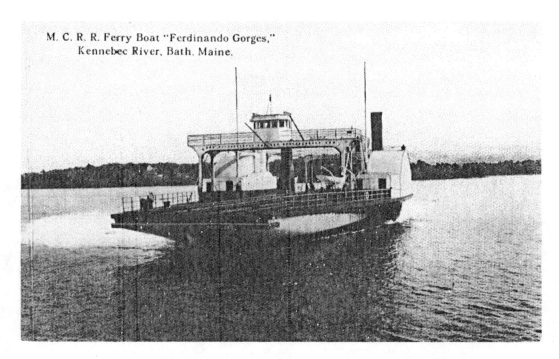

The first railroad-car ferry used at this crossing entered service in 1875. The *Ferdinando Gorges*, which went to work here in 1903, could carry nine average passenger coaches or 15 average freight cars as well as locomotives. The ferry was named after an early settler who obtained a grant from the English Crown to develop a tract of land near what is present-day South Berwick, under the stipulation that he build a mill there. He gave proof of his fulfillment of the terms by sending back to London the first cornmeal ground in his mill.

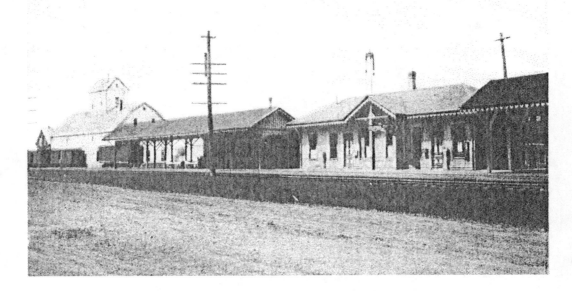

Pittsfield, Maine, 101 miles from Portland, was the Maine Central's junction with the Sebasticook and Moosehead Railroad which later became the Maine Central's Harmony branch. The station, built in the 1880's, served both lines. Note the two scales on the platform for weighing LCL freight shipments and baggage. Although Maine is noted for paper and wood pulp, the lowland southern regions were dotted with small farms, and growing grain was important business as evidenced by the grain elevator at the left.

Newport Junction, Maine, was a busy place in the hey-day of steam railroading. Located 110 miles from Portland, it was the junction between the Dover-Foxcroft line and a branch to Bangor, as well as a connection with the Bangor and Aroostook. Its strategic location made it a major gathering point for freight coming from eastern and northern Maine, the Aroostook Valley, and the Canadian Maritime provinces.

Here's a switch tender standing by his post, and at the left, leaning against his shanty is a railroad crossing guard, ready to lower the gates at train time. In earlier times it was common practice for railroads to assign faithful workers to such positions rather than forcibly retire them when their over-the-road days were done.

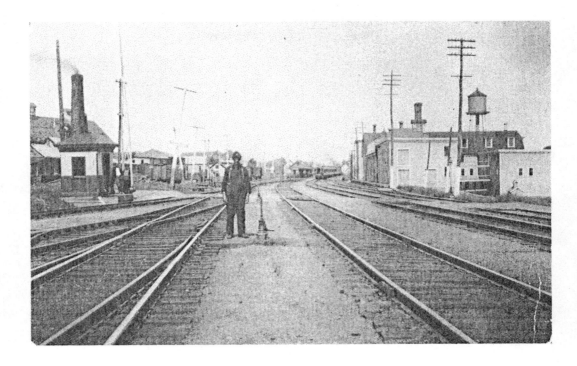

Silver Lake. Dexter. Me.

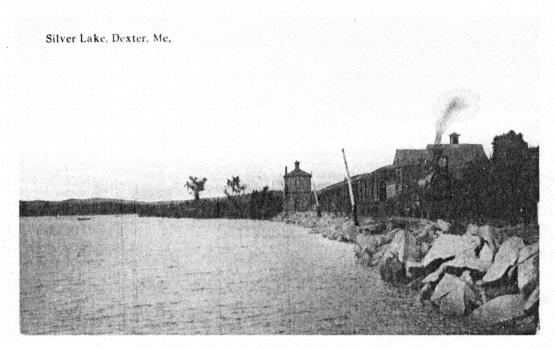

On the line running due north from Newport Junction, the Maine Central passed scenic Silver Lake at Dexter. Here we see a passenger train passing one of the road's enclosed water tanks while enroute to Dover-Foxcroft. Because of the severity of the Maine winters it was common practice, in the steam era, to build enclosures around the pipes beneath the tank, which could then be heated with a stove to prevent freezing.

An important shoe factory was located in Dexter, which in addition to regular shoes made woodsmen's boots and river driver's calks, the spiked boots worn to help loggers walk on top of floating logs. Their wares, manufactured to the present day, have become synonymous with "Down East" quality.

Dexter also boasted a sprawling machine shop and foundry operated by the Fay and Scott Company which engaged in building and repairing equipment and machines used by loggers, shoe factories, and the local textile industry.

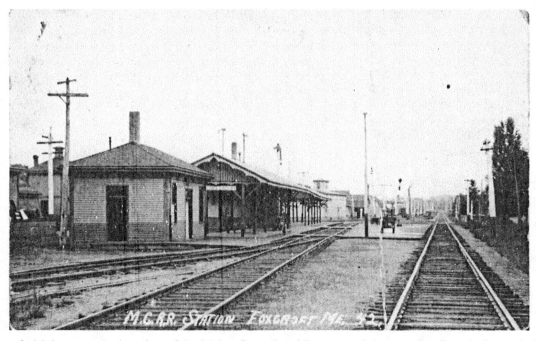

Dover-Foxcroft, Maine, was the junction of the Maine Central and Bangor and Aroostook railroads. Instead of combining in one station, each line maintained its own facility for the inconvenience of their passengers and operators.

One of the interesting local industries around Dover-Foxcroft was liming. Limestone blocks were quarried and broken up, then thrown into a kiln and baked to make quicklime for fertilizer and mortar. The quarries and ruins of some turn-of-the-century kilns remain, and are fascinating to visit.

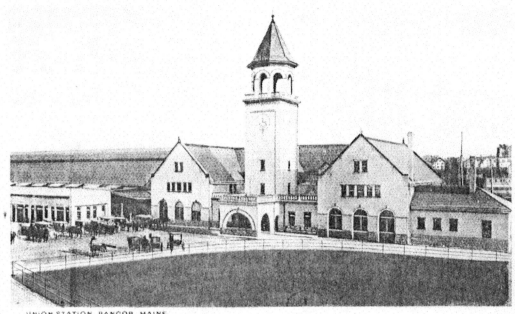

UNION STATION, BANGOR, MAINE.

Bangor is the largest city in central Maine. First settled in 1772 and incorporated as a town in 1791, it grew into a city by 1834. It was first known as Kendusky Plantation, and later as Sunbury. Tradition says that that it became Bangor when, in 1791, the Reverend Seth Nobel was sent to Boston (Maine was still part of Massachusetts in those days) to arrange for the incorporation. The good Reverend was humming the old church hymn "Bangor" while the clerk was filling out the forms. When the clerk asked the name of the community, Nobel, preoccupied with his humming, replied with the name of the hymn, and Bangor it became.

Bangor is 137 miles from Portland by rail. The Union Station was located alongside the Penobscot River, at the head of Penobscot Bay. The main station had the usual centrally located clock tower which easily dominated the Bangor skyline. The covered train shed was a later addition to the main building.

It's interesting to reflect that this modern city, right on the Atlantic coast, was the destination for river log drives as late as the 1920's. Extensive logging was carried out in the Allagash region of northern Maine, and the logs were driven the entire length of the Penobscot River to reach the sawmills around Bangor. In the quarter century before 1900 an estimated 250 million board feet of lumber passed through Bangor annually, and the city ranked second in the nation in originating lumber shipments.

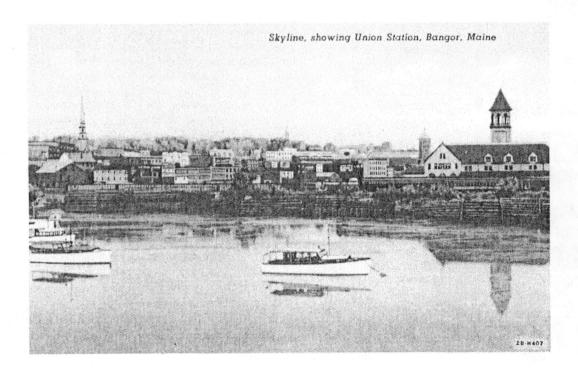

Skyline, showing Union Station, Bangor, Maine

PENOBSCOT RIVER, BANGOR, ME.

The lower yard at Bangor stretched along the river with trains leaving there for Bucksport and the Penobscot Bay steamers. In this view the station is hidden by the smoke from the train.

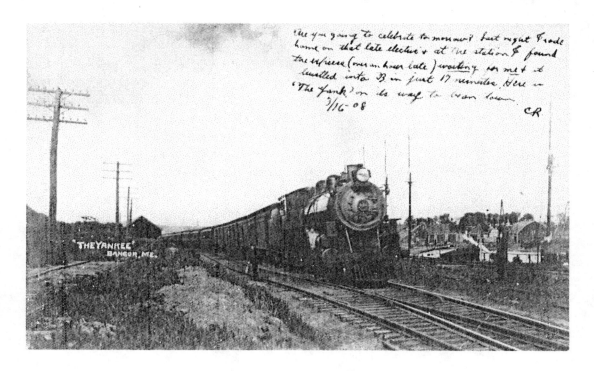

The Maine Central, like all of the state's other major railroads, operated special passenger trains which carried passengers and summer tourists down to Maine's coastal resorts. This photographic card shows the crack express, *The Yankee* on its way out of Bangor headed for Beantown. That big piston-valved 4-6-2 Pacific-type locomotive on the head end was the latest in motive power back on St. Patrick's day 1908, when this card was mailed.

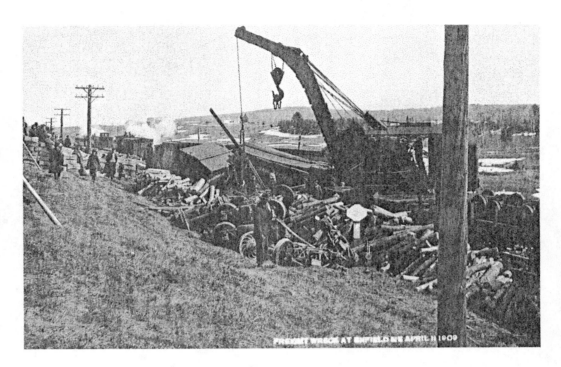

There were spare parts a-plenty after this mixup. Train wrecks will happen, and this time it was at Enfield on the line to Mattawamkeag and Vanceboro. This wreck happened on Sunday, April 11, 1909 and the "big hook" has been called in to help sort out the mess. From the amount of wreckage it looks like quite a few cars have been reduced to kindling.

Salvageable cargo has been pulled out of the wreck and is piled up to the side while metal parts like wheels and car truck frames are being piled up in the middle. The odd-looking stacks beyond the wheel pile are bundles of cedar shingles, while salvaged pulpwood is piled up alongside the tracks.

Interestingly, while the wreck brought out the local photographer, no account of the wreck is to be found in the newspaper of the day.

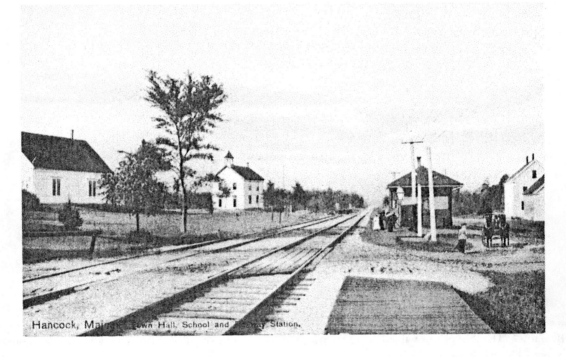

Hancock, Maine was about 40 miles from Bangor on the line to the Mount Desert Ferry. Hancock was then a rural farming hamlet through which summer excursion trains passed on their way to the ferry to off-shore island resorts. The station existed until 1933.

The Bar Harbor Express terminated at Mt. Desert, where steamers departed for Bar Harbor on Mt. Desert Island. The Bar Harbor trains were expresses operated jointly by the Boston and Maine and the Maine Central carrying passengers from metropolitan Boston to the Maine coast. On one memorable occasion a woman who had been instructed by her friends to meet them at the Mt. Desert Ferry approached the conductor and asked if the train would stop there to let her off. The conductor replied with a twinkle, "I should hope so, because if it doesn't we're all in for one hell of a ducking!"

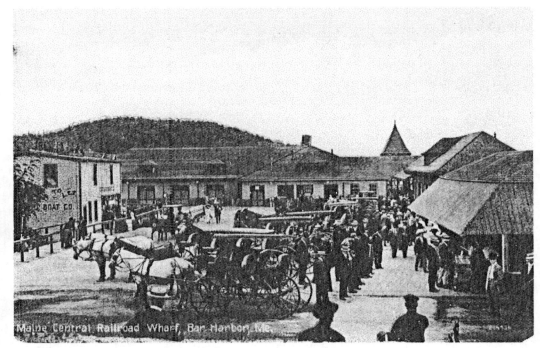

Maine Central Railroad Wharf, Bar Harbor, Me.

Travel to Bar Harbor was quite a pastime as is suggested by the parade of depot hacks waiting to take passengers to the resort hotels.

Bar Harbor Express was the elegant fast passenger train jointly operated by the Maine Central and the Boston and Maine. The combination of railroad passenger trains with steamers made for economical and memorable trips and vacations for the summer rusticators.

The Bar Harbor Express made its first run on June 29, 1885, running from Boston to Bangor. In 1892 the northern terminal was changed to the Mt. Desert Ferry landing, and in 1905 the southern terminal was changed to New York City, with the train picking up

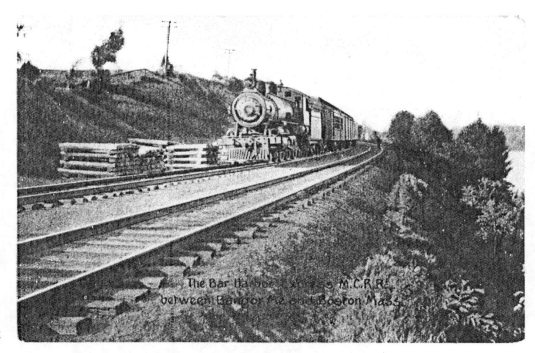

The Bar Harbor Express M.C.R.R. between Bangor Me. and Boston Mass.

sleeping cars at Boston. During the depression the northern terminal was again changed, this time back to Ellsworth and the steamer connection was abandoned, although service continued until the end of the 1960 season.

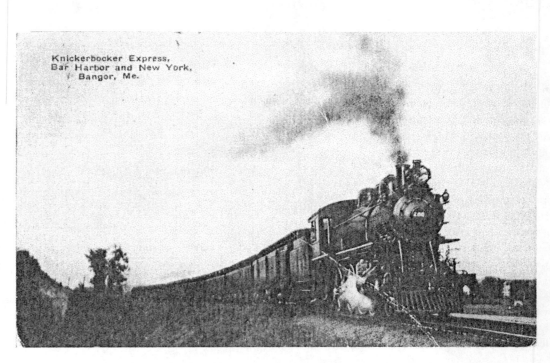

Knickerbocker Express,
Bar Harbor and New York,
Bangor, Me.

The Knickerbocker Express was the Maine Central's name train to New York, home of the "Knickerbockers." The train ran from Mt. Desert Ferry through Bangor, as a southbound counterpart to the *Bar Harbor Express*. It ran on Tuesdays, Thursdays and Sundays from mid-June until the end of September. In the 1912 example shown here, the *Knickerbocker* was headed up by a big Brooks-built ten-wheel 4-6-0 type with unusual inboard piston-valved cylinders. The ten-wheel-type locomotive was developed from the American Standard 4-4-0 type when heavier locomotives were needed to pull heavier loads. To spread the weight of the locomotive and improve traction, an additional set of driving wheels was added.

The Maine Central crossed Pennamaquan Lake north of Pembroke enroute to Calais on this long wooden trestle. The use of embankments and causeways in conjunction with trestles to cross lakes was a common practice. Often trestles were built first and gradually replaced with an embankment by pouring fill off the trestle. This line from Washington Junction to Calais was originally built by the Washington County Railroad which was later absorbed by the Maine Central.

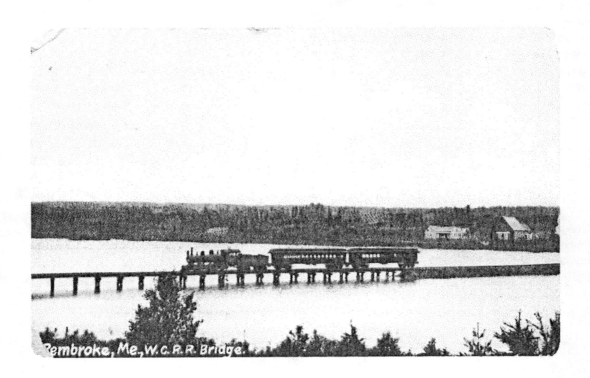

Pembroke, Me., W.C.R.R. Bridge.

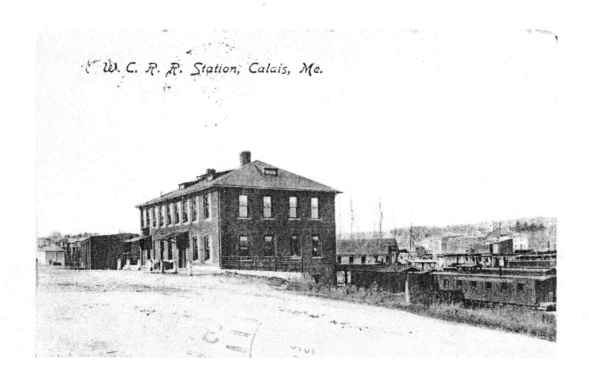

W. C. R. R. Station, Calais, Me.

At Calais the Maine Central connected with the New Brunswick Southern back in 1911 when this card was mailed. At 269 miles from Portland, Calais was one of the northernmost outposts of the system. The station seen here was originally constructed by the Washington County Railroad in 1898, then acquired by the reorganized Washington County Railway in 1903 before finally passing into the hands of the Maine Central. The Washington County Line connected with the Maine Central at Washington Junction on the Mt. Desert branch, and after passing through Calais on the Canadian border, terminated at Princeton.

Although Maine is best known for its paper, wood pulp, and potatoes, it also had its share of textile mills. Attracted by the ample water power provided by the St. Croix River, this cotton mill was built on the Canadian side.

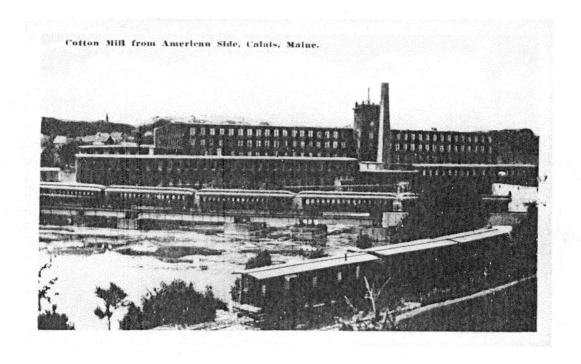

Cotton Mill from American Side, Calais, Maine.

BANGOR and AROOSTOOK RAILROAD

The Bangor and Aroostook was a relative latecomer on the railroad scene. It was organized in 1891 to build a line between Brownville, Maine, on the European and North American railroad, one of the predecessors of the Maine Central, and Van Buren — a distance of about 200 miles, including branches. In 1894 additional lines were built to Presque Isle and Houlton. The following year a line was run from Oakfield to Ashland. In 1899 the BAR bought the Bangor and Piscataquis and in 1903 took over the Fish

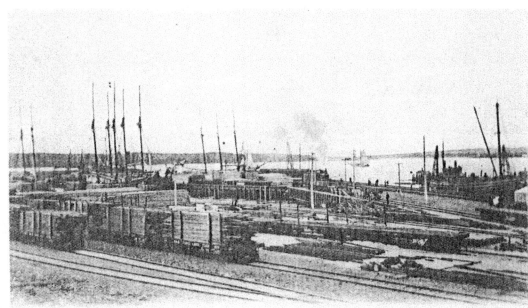

Freight Wharves. B. & A. R. R., Stockton Springs, Me.

River Railroad, gaining access to Fort Kent on the Canadian border. In the 'teens and 'twenties the BAR continued to expand with branches to mills at Millinocket, a connection with the Canadian National, and connecting trackage across the Aroostook Valley eventually totalling some 630 route miles. Its record of success is recorded in the vast quantities of potatoes and forest products hauled on its trains.

Stockton Springs, on Penobscot Bay, was one of the outlets where the Bangor and Aroostook transferred its lading to ships. The line's first trackage was laid in Aroostook County and then southward toward the tidewater terminals at Stockton Springs and later at Searsport which became milepost 0 on the Bangor and Aroostook.

In this picture, which dates from the 1890's, the Cape Jellison harbor at Stockton Springs is clogged with schooners being loaded from flatcars piled high with lumber. At the turn of the century schooners like these were the handy bulk-freight haulers of the coastal trade.

By the turn of the century the Bangor and Aroostook had built a deep-water terminal to accomodate ocean-going steamships. It featured the impressive 800-foot Mack Point railroad wharf shown here at Searsport, four miles south of Stockton Springs.

B. & A. Railroad Wharf, 800 Feet long, 150 Feet wide. Searsport. Me.

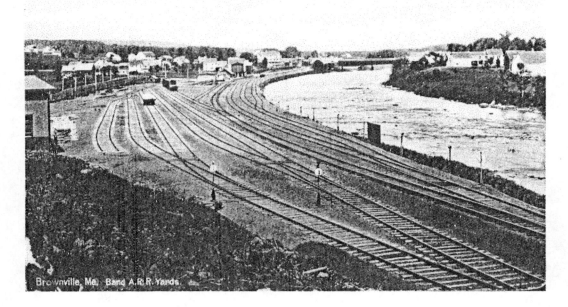

At Brownville the lines from the Aroostook Valley merged with the coastal lines and the Canadian Pacific which came down from Brownville Junction, three miles north. The yards were and still are the major consolidation point for the Bangor and Aroostook. Vast tonnages of paper and pulp products travel through these yards enroute to the rest of the country.

At Greenville Junction on the southern shore of Moosehead Lake, the Bangor and Aroostook connected again with the Canadian Pacific. The big structure in the middle of this picture, seen next to the water tank, is a covered railroad coal shed with a bucket loading crane. Covered coal sheds were common in Maine to help keep the coal dry, an important consideration in winter months when breaking up frozen chunks of coal was a particularly unwelcome job. Coal from the shed was shoveled into a big iron bucket which would then be swung up onto the locomotive tenders to be tipped into the bunker.

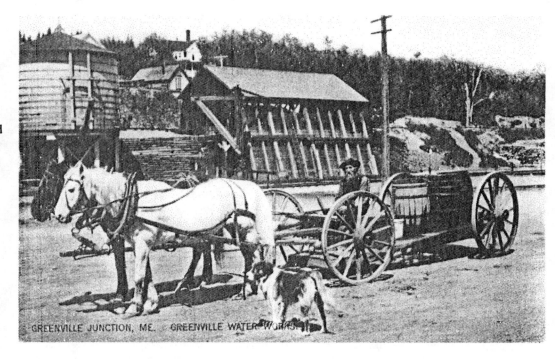

The curious-looking wagon in the foreground is a stone boat sledge. The heavily timbered carriage is suspended below the axles and can be lowered so heavy objects can be rolled on, before the carriage is raised back up for travel. The rig relates to spring plowing in New England, where winter freezes bring many submerged stones to the surface, leaving the farmers to haul them away as best they can. Rather than lift the heavy stones farmers would roll them onto the sledge and move them to the edge of the field. In the fields or on muddy ground oxen would drag the sledge, but on longer hauls the axles would be brought up and the cargo "wheeled out."

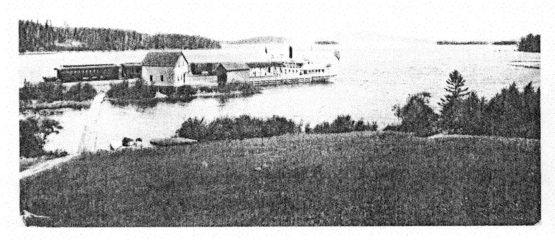

At Greenville Junction the Bangor and Aroostook maintained a wharf for passengers transferring to lake steamers bound for the summer resorts, known as "camps" or in the case of the more elaborate examples, "houses", located on the shores of Moosehead Lake. This combined train and boat service was maintained by the railroad and the Coburn Steamboat Company from 1892 until 1937, when better roads and competition from automobiles put an end to it. At its height the steamboat company operated eight vessels on lake waters. In this view the steamer *Marguerite* is shown taking on passengers from the train on the dock.

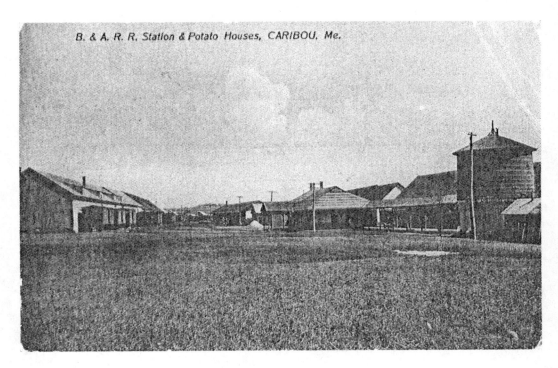

B. & A. R. R. Station & Potato Houses, CARIBOU, Me.

Both the Bangor and Aroostook and the Canadian Pacific railroads had depots and yards at Caribou. On the BAR, Caribou was 77.6 miles from Oakfield. Originally there was a wood station, built in 1894, with a long canopied platform as shown in this postcard. This was replaced in 1929 by a more sturdy brick station. Also shown in this view are potato warehouses. These large storage buildings are used to store harvested potatoes from Aroostook Valley farms. Potato houses are insulated against winter's cold as potatoes cannot be allow to freeze or they will rot. During winter months long trains of refrigerator cars wound their way down from the Aroostook Valley to the Maine Central interchange and to the rest of the United States.

The Bangor and Aroostook connected with the Canadian Pacific coming down from Canada near the international border bridge at Houlton. To reach Houlton the BAR crossed the Meduxnekeag River on this five-span girder and deck truss bridge.

Presque Isle is in the heart of the Aroostook Valley, the potato-producing region of the northeast. Although this station was a neat Victorian-styled structure, many of the Bangor and Aroostook stations were much more utilitarian than those of the Maine Central. In the country traversed by the BAR, passengers were fewer, and freight, lumber products, and potatoes were the most important money makers carried by the rails.

CANADIAN PACIFIC RAILWAY in Maine

The Canadian Pacific was the final expression of many railroad proposals, some dating all the way back to 1843. The plan was to build a line from Halifax, Nova Scotia, on the Atlantic coast to Montreal. It called for cutting an 800-mile swath across southern Canada and occasionally poking down into New England, but was not realized until 1888. This was when the Canadian Pacific finally constructed track eastward across Maine to Mattawamkeag, and by using the Maine Central's tracks to Vanceboro completed the traversal of Maine.

Onawa was almost midway between the Canadian Pacific's junctions with the Bangor and Aroostook at Greenville and Brownville and was the only station stop for a dozen miles in either direction.

C. P. R. R. Station, Lake View, Maine.

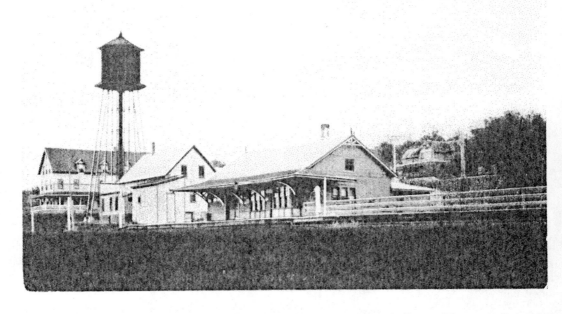

With its location at the southern tip of Schoodic Lake, Lake View was most aptly named. The station was built in 1889, the year after the Canadian Pacific Railway was completed. The American Thread Company operated a big mill in Lake View, which contributed its freight to the Canadian Pacific.

SANDY RIVER
and RANGELEY LAKES RAILROAD

Two-foot-gauge common-carrier railroads were unique to Maine, and the first one built was the Sandy River Railroad, in the late 1870's. Other roads were built following the example, and finally the Sandy River and Rangeley Lakes Railroad was formed by the consolidation of the several lines operating in Franklin County into a single Y-shaped system in 1908. For a time around the First World War it was operated as a part of the Maine Central system. At the time of abandonment in 1936, it was the largest two-foot gauge railroad in the United

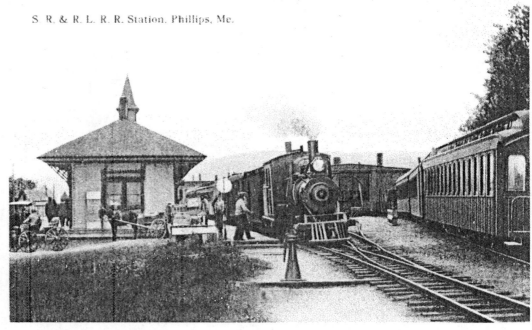

S. R. & R. L. R. R. Station, Phillips, Me.

States, having 120 miles of track, over 300 freight cars, and 20 locomotives.

Phillips was home base for the railroad, housing its general offices, a ten-stall enginehouse, car and machine shops, and service facilities. The station, erected in 1905, was located on a curve opposite the shops. The station is still standing today, home of a veterans organization.

There's a story dating from before the days of consolidation about the time that the Phillips and Rangeley received a letter from a western railroad demanding payment for repairs made to a freight car. The letter, which was obviously intended for the Philadelphia and Reading, dutifully was answered by the superintendent informing the sender that he forbade his two-foot gauge cars from leaving Maine, and if one had actually crossed the Mississippi he would appreciate its prompt return, by parcel post.

The small stone station at Marbles on the grounds of the Rangeley Lake House was at the far end of the SR&RL. It was erected for the convenience of passengers arriving at the hotel on the crack *Rangeley Express*. The *Rangeley Express* was the last link for passengers summering in the Rangeley Lakes region, many of whom came from New York over the rails of the New Haven and the Maine Central to transfer to the narrow gauge at Farmington. Service into Marbles ended in the 1920's, and the station later became a private residence. Marbles is right on the lakefront, and canoes and rowboats could be rented by the day at the station.

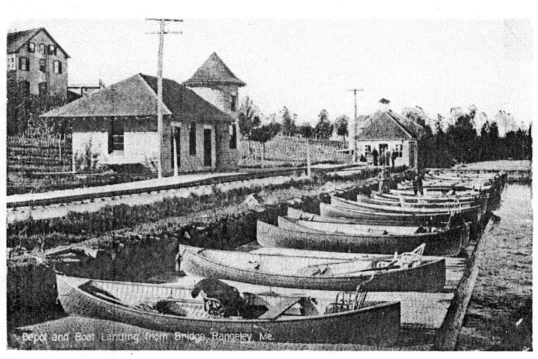

Depot and Boat Landing from Bridge, Rangeley, Me.

KENNEBEC CENTRAL RAILROAD

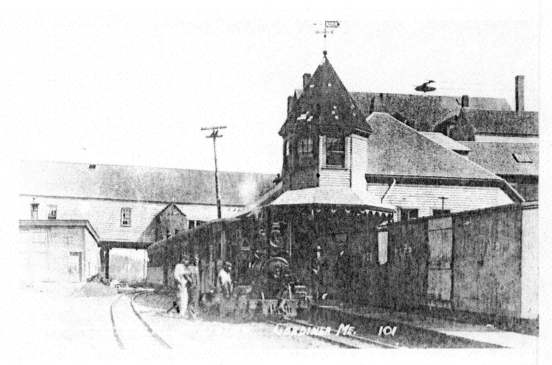

Only five miles long, The Kennebec Central was the shortest of the Maine two-footers. Built in 1889/90, it ran until 1929. It boasted four locomotives, five passenger cars, and 13 freight cars. Its sole purpose was to serve the Old Soldiers Home in Togus at the other end of the line from this terminal. It did this by hauling coal from the Kennebec River Coal shed to Togus and carrying the old soldiers back and forth from the home to Randolph and Gardiner, on the banks of the Kennebec River.

Randolph had a Queen Anne-style station, a two-stall engine house, a large government coal shed and a passenger car house. Coal was loaded on the coal cars in a two-track coal shed to the left of these views. Engine number 1, shown above, was named *Volunteer*, while engine number 2 in the lower view was built by the Portland Company and named *Veteran*. The covered bridge in the background, which crossed the Kennebec River, was dismantled in 1896.

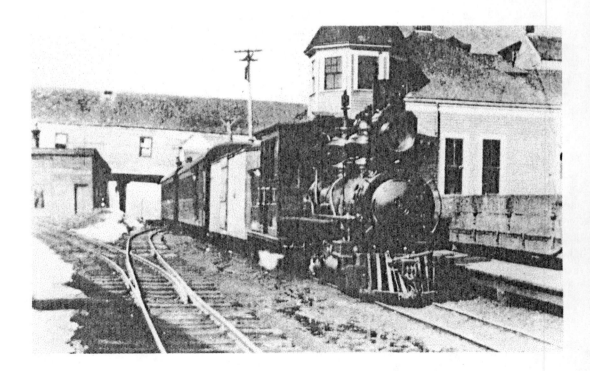

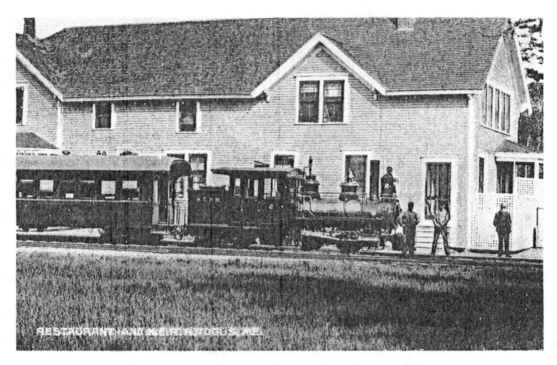

Togus was at the other end of the Kennebec Central, where the track ended behind the Commissary and Quartermaster's buildings. Togus was a self-sufficient veteran's hospital, with a chapel, an opera house, farm, barracks, and hotel; weekly band concerts were featured in the central square.

MONSON RAILROAD

The two-foot-gauge Monson Railroad was built in 1884 from a connection with the Bangor and Piscataquis, later to become a part of the Bangor and Aroostook, at Monson Junction to Monson, a distance of about six miles, with an extension to the slate quarries a bit further on. Known as the "two by six," since the track was two feet wide and six miles long, the Monson had four locomotives, 24 freight cars and one passenger car. It ran for 59 years before abandonment in 1943.

Monson housed the general offices, a small turntable, a two-stall engine house and an abbreviated single-stall car house. The station was painted red with white trim. In this view, prominent in the foreground is a stub turnout, an early type of track switch in which the approaching rails move — a type used by the Monson from beginning to end.

Because the Monson was an industrial branch line, operations were always a bit informal. In its later years an ICC inspector noted that the locomotives had no headlights, only to be told by employees that the railroad had no plans to run at night!

WISCASSET WATERVILLE & FARMINGTON RAILROAD

The two-foot gauge Wiscasset and Quebec Railroad was built in 1894 and reorganized in 1901 as the Wiscasset Waterville and Farmington. The railroad owned nine locomotives, seven passenger cars, and 94 freight cars. Gradual decline in freight loadings spelled doom for the line, and it was abandoned after a minor wreck blocked the main line in 1933.

Wiscasset was the line's junction with the Maine Central, the WW&F's depot sitting right at the crossing of the narrow and standard gauge rails, north of the town area. The narrow gauge reached the waterfront interchange yards over some trestling.

Today little remains of the two-foot gauge at Wiscasset, and Wiscasset's most famous residents are a pair of decaying schooners, the *Hesper* and the *Luther Little,* abandoned alongside the remains of the wharf.

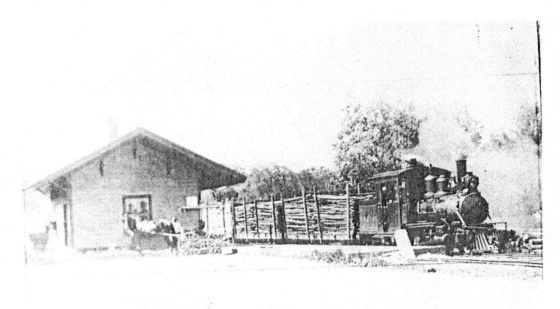

Head Tide, nine miles north of Wiscasset, featured a small depot and a team track siding where cars were loaded directly from horse-drawn wagons. Seven of the WW&F's depots followed the basic design of this one. The final small wreck which closed the WW&F forever took place just north of this station.

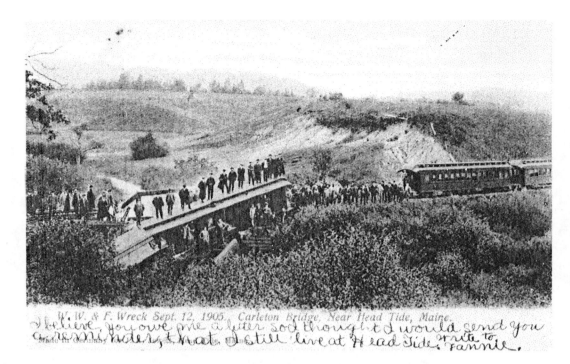

W. W. & F. Wreck Sept. 12, 1905., Carleton Bridge, Near Head Tide, Maine.
I believe you owe me a letter so I thought I would send you a few lines, that I still live at Head Tide. Write to Fannie.

The most spectacular wreck on the WW&F happened on September 12, 1905, when locomotive No. 4 derailed and went for a swim in Carleton Brook. Fortunately, no one was hurt seriously. It took two weeks to fish No. 4 back out and get it on the track again. The scene inspired one of the very rare hand-colored German postcards of a train wreck. The most newsworthy feature of the pile-up was that about 65 members of the Masons' Waterville Lodge were aboard the train on an outing to join their Wiscasset brothers when the mishap occurred, and for years afterward the event was referred to as the "Masons' Wreck."

Cooper's Mills, 20.4 miles from Wiscasset, featured a run-around siding and a station of a design different from most of the WW&F's depots. Downie Brothers Circus was coming to town and practically the entire end of the depot was plastered with their posters when this picture was taken. Many WW&F stations were painted as was this one, in an attractive two-tone green design.

BRIDGTON AND SACO RIVER RAILROAD

BRIDGTON AND SACO RIVER R. R. STATION, NORTH BRIDGTON, ME.

The Bridgton and Saco River was built in 1882 and extended to Long Lake and Harrison in 1899. After 28 years' service the line to Harrison was abandoned and in 1941 the balance of the line was torn up. The 20-mile line had eight locomotives, 73 freight cars, and seven passenger cars. North Bridgton had the station and freight house seen here, and today the station continues in use as a private residence.

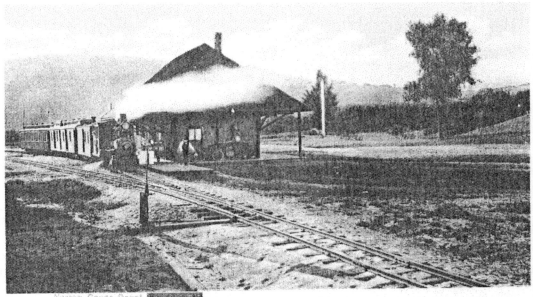

Narrow Gauge Depot.
Harrison, Me

Harrison had a small depot, a turntable, a single-stall engine house, and for keeping the fancier passenger coaches out of the weather, a coach house. There was also a small yard set on a curve at the north end of Long Lake.

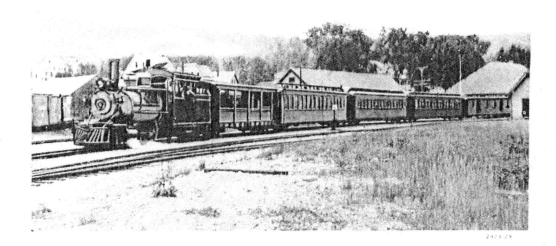

The B&SR ran excursions which ended at Harrison, and many summer visitors came by rail to the camps around Long Lake. The village of Harrison came to have several small industries which shipped their products out on the railroad. The lower view of Harrison, which the card's publisher tells us depicts the *Harrison Express*, was taken shortly after the line arrived there in 1899, while the excursion photo above was taken around 1910 and shows the addition of many more buildings around the railroad's terminus.

After the road was abandoned in 1941, some of the surviving equipment was purchased by Ellis D. Atwood, who used it on his South Carver, Massachusetts, cranberry plantation where happily, at the time of this writing, some is still in active service on the Edaville Railroad.

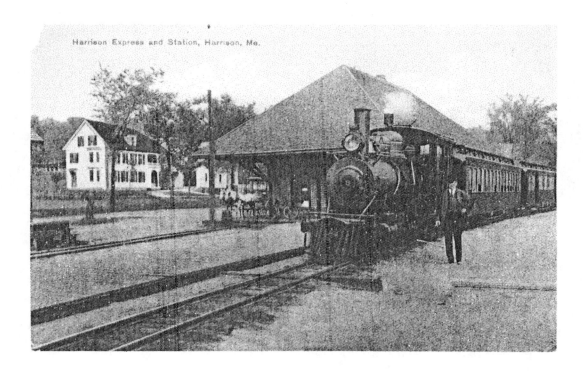

Harrison Express and Station, Harrison, Me.

INDEX

104

A PARTING SHOT